The Façades of Paris

THE FAÇADES OF PARIS

WINDOWS, DOORS, AND BALCONIES

WATERCOLORS BY
DOMINIQUE MATHEZ

New York · Paris · London · Milan

Introduction

Imperious and unmoving, they rise before us. Unfurling their silent tales down streets and boulevards, the façades of Parisian buildings draw the city, sketch its perspective angles, and narrate its history, harmony, and poetry. Doors, windows, and balconies set within an abundance of rich ornamentation, obediently arranged within the disciplined lattice of broad avenues, all become pretext for a journey that has nourished Dominique Mathez's drawings and watercolor paintings, gathered together in the spirit of the French poet Jacques Prévert's inventory lists.

In Second Empire Paris, reshaped by Baron Haussmann, flâneurs—curious amblers from all walks of life—could lift their heads if they so wished and, forgetting the flow of passersby, suddenly discover the arabesques, spirals, bows, curves, and interlacing forms spilling forth from the surrounding still and tranquil façades. A whole universe of subtle movements and finely crafted décor spreads from apartment buildings to town houses, or hôtels particuliers, from the Rue de Rivoli up to the Avenue de l'Opéra, the Place de la République to the Boulevard Saint-Germain. A host of treasures awaiting discovery, paths to stroll along, step

by step, with the same pleasure of a delicious read. Here, nothing is left to chance. The floral motifs and the vegetation adorning cast- and wrought-iron banisters are signs, symbols, and references borrowed from the historic periods of the last French kings and from myths whose memory is held by collective imagination, imbedded as it were into the city's very walls.

Thus, in the nineteenth century, finely carved bowed balusters on opulent balconies are appropriated from the Sun King's decorative style. The rare, curvaceous railing on Rue du Regard (page 78), with its harmonious forms in wrought iron, is a notable ambassador of Louis XIV's influential style, reproducing the outlines and curves of its signature arabesques. Its composition in spiraling curls, with double-arched volutes, acanthus leaves, roses, and rinceau tendrils, represents sculpted vegetation.

The flowery aesthetic of Louis XV's reign goes on to elevate the metal art done in his rococo style, combined with mineral and vegetable motifs. Acanthus leaves, shell, coral, and flower wreaths adorn rococo furnishings and intrude upon the delicate décor of a window railing, or above a carriage entrance on Boulevard des Filles-du-Calvaire (page 99). The bottom railing on Rue de la Pépinière (page 33) elegantly shows a perfectly mastered interpretation of this style. In effect, it pulls from the classic codes of the eighteenth century, via a balanced composition of flat iron spiral curves embellished with acanthus leaves, delicate bases, rosettes, "frog legs," interwoven elements, and—in the center—an oval motif decorated with a large palm leaf.

An idealized view of Greek antiquity is subsequently brought into fashion during Louis XVI's reign. A myriad of Greek motifs can be found as a result in the friezes as well as the railings on Rue des Grands-Augustins and Rue de Rennes (page 14), and Boulevard Saint-Germain (pages 82–83). This motif is composed of broken-up straight lines and the return of square angles. Vases are also largely reappropriated in compositions, where they are always to be found

in the center, often framed by flowering garlands or laurel leaves. On the balcony on pages 82–83 garlands, characteristic of the king's bucolic taste, spill from the vase handles to hook onto helixes. Elegant and refined, the railing on Rue de Rennes (page 60, bottom) is very classical and clearly borrowed from this same style, following that of the rococo period. The whole ensemble appears light and balanced: profiles are slender and décors harmonious. The frame interior draws from the previous century's ironworking codes, featuring volutes with solid tips and double bases complemented with flower garlands, scalloped, knotted ribbons, Greek motifs, and an oval coat-of-arms adorned with a woman's head in profile.

Still within the purest spirit of Louis XVI's aesthetic, variations of balcony railings on the Boulevard Saint-Germain, the Rue de Tolbiac, and the Boulevard du Montparnasse (pages 112 and 113) pick up on all these classic characteristics, but nevertheless introduce a central, distinctive motif composed of a quiver with interlaced arrows and clubs, crimped together with knots. Rather common in the eighteenth century, the quiver symbolizes monarchic strength and power. Previously used by the Romans, and later reintroduced on monograms under Louis XVI, it is once again used in the nineteenth century.

Clearly demonstrating the classic models described above, the balconies and windowsills on Boulevard Saint-Martin (pages 40 and 41), as well as the railing on Rue Sévigné (pages 24–25), represent a more personal, particular style. The architect's designs do not reference an identifiable style and are probably the product of his imagination and—it should be mentioned—are difficult to describe. On pages 40 and 41, large panels are composed of a series of repetitive, solid barrel balusters, featuring representations of children and birds mixed with stylized, interlacing foliage, palmettes, and nondescript decorative motifs.

Respectful of its predecessors' rigorous nature, the architecture that subsequently comes into being transforms the city by setting it in order. Georges Eugène Haussmann, a subtle urban planner and reformer, knew how to skillfully combine

the traditions and styles of the City of Light with its necessary modernization. Designed using the same model, these façades, which lend a rhythm and unity to the capital's streets and whose ornaments record history in small strokes, are the product of a way of life and a social structure propelled forward by Napoleon III.

Under the Second Empire, Paris becomes a theater for appearances meant to dazzle the rest of the world. The amenities and comforts brought by the Industrial Revolution inaugurate an urban lifestyle in which theaters, world fairs, leisure, pleasure, and gardens—inspired by London's parks—occupy a growing portion of daily life. In turn, Haussmann's building façades are the reflection and embodiment of this. Rising to six floors in height, for the most part their uniform verticality designed according to strict norms displays society's composition at the time. While the ground and first floors are devoted to merchants, the second, so-called "noble floor," enjoys the largest spaces with long balconies, and is reserved for a very affluent population. The levels above, for their part, host a more modest segment of the bourgeoisie, and the top floor beneath the rooftops is for their servants. Similarly, the ornamentation punctuating these façades—dense and ostentatious on the first floors—diminishes as one moves higher up the building.

This immense building project, which lasts for seventeen years, will make the city sanitary and enlarge its major axes, facilitating the deployment of armed troops in case of rioting or preventing barricades. Henceforth, almost two-thirds of the capital's buildings are constructed using Haussmann's design and include the technical innovations of their time. Thus, while metal art is ancient, cast iron doesn't appear in ornamentation until the nineteenth century, with industrialization's early stages. In addition, due to growing demand, the new method of molding signals real technical advancement, as it enables the serial production of a standardized model. Now driven by time and money, the economy opens up new artistic and industrial possibilities, as much in quantity—from now on

mass-produced—as in the diversity of motifs and associations. Gathered in catalogs for professionals, various models for balconies, pilasters, banisters, and benches, extending as far as troughs and culverts, are offered to architects and contractors as early as 1840. Drawing from this profuse production of decorative elements, Dominique Mathez has composed a selection in painstaking detail, offering a tender perspective on Haussmann's Paris.

And so, the city speaks to the curious flâneur, asking them to reach beyond appearances, to delve into the palm-leafed rosettes, the olive branches forming bird-like figures, the hidden meanings, charged with history, harbored within these façades that tell of the city. Through the magic of drawing and watercolor, they transform a point of view into a focal point. Generous and creative, Parisian balconies offer us their horizons.

—Christophe Averty with Joël Orgiazzi

Christophe Averty is an art journalist.
Joël Orgiazzi is an artisanal metalworker, awarded Meilleur Ouvrier de France in 1986.

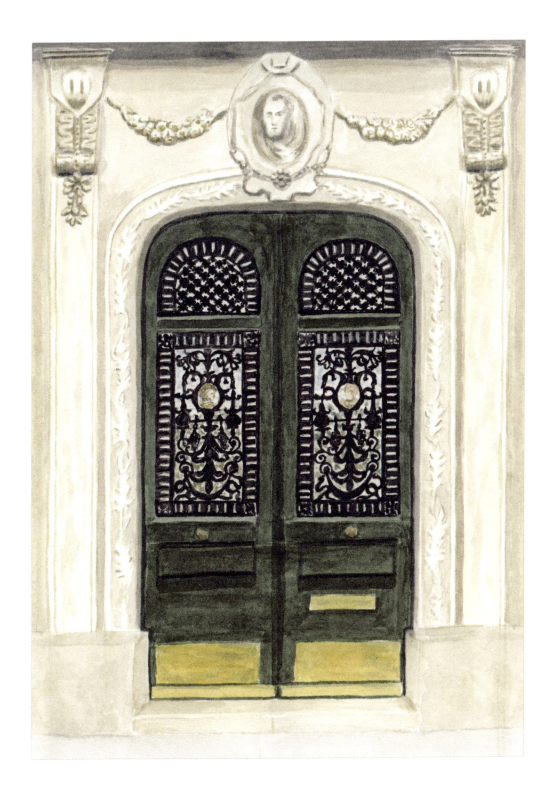

ABOVE AND FOLLOWING PAGES
Quai aux Fleurs,
House of Héloïse and Abélard

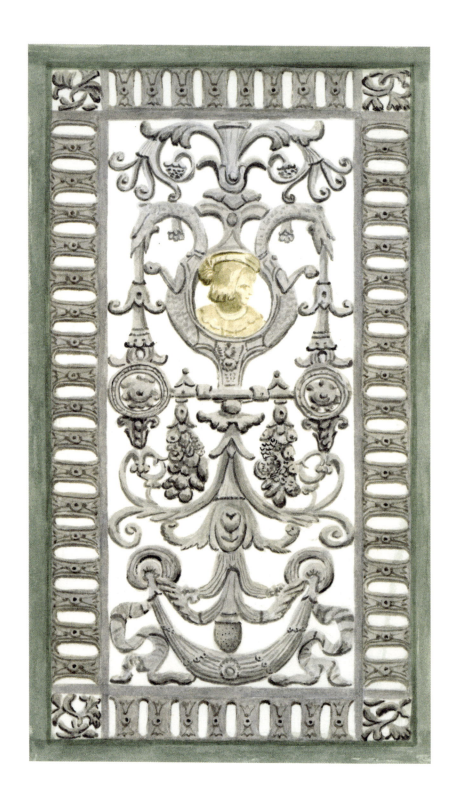

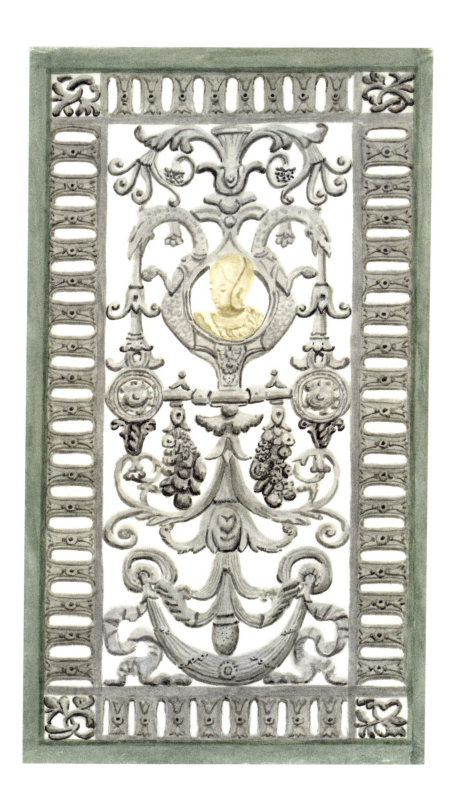

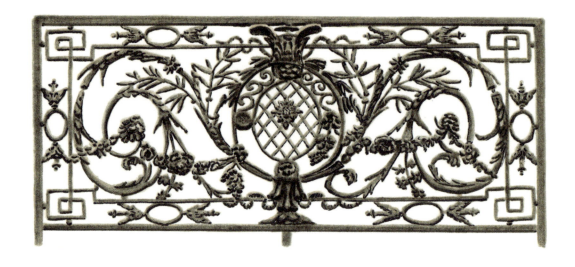

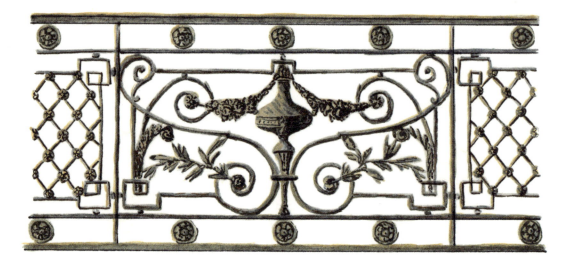

TOP AND OPPOSITE
RUE DES GRANDS-AUGUSTINS

BOTTOM AND FOLLOWING PAGES
RUE DE RENNES

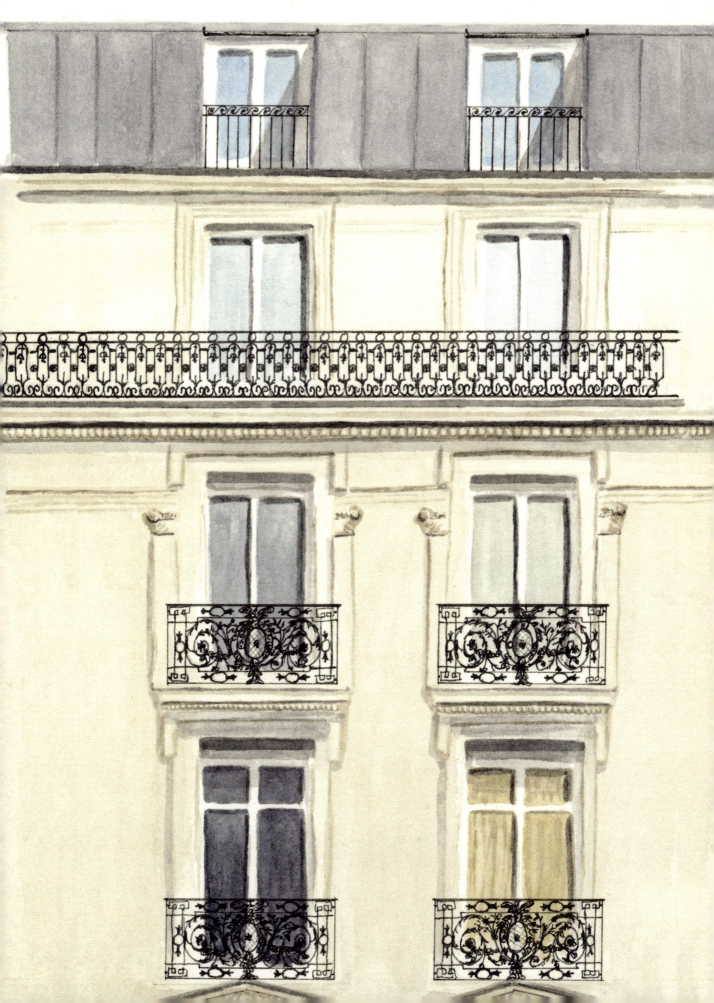

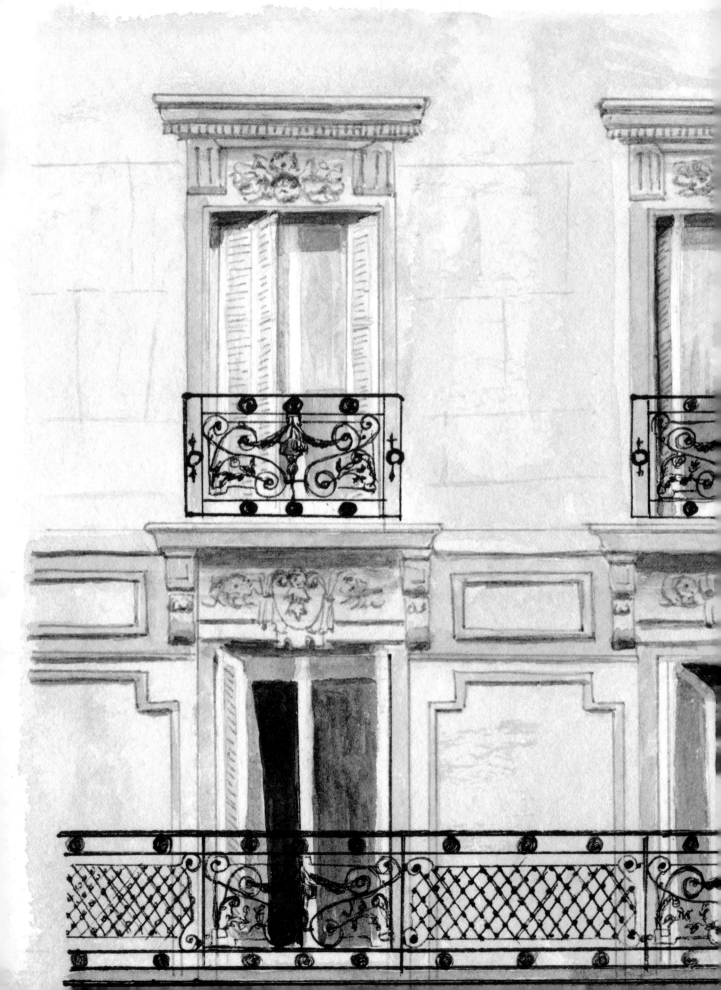

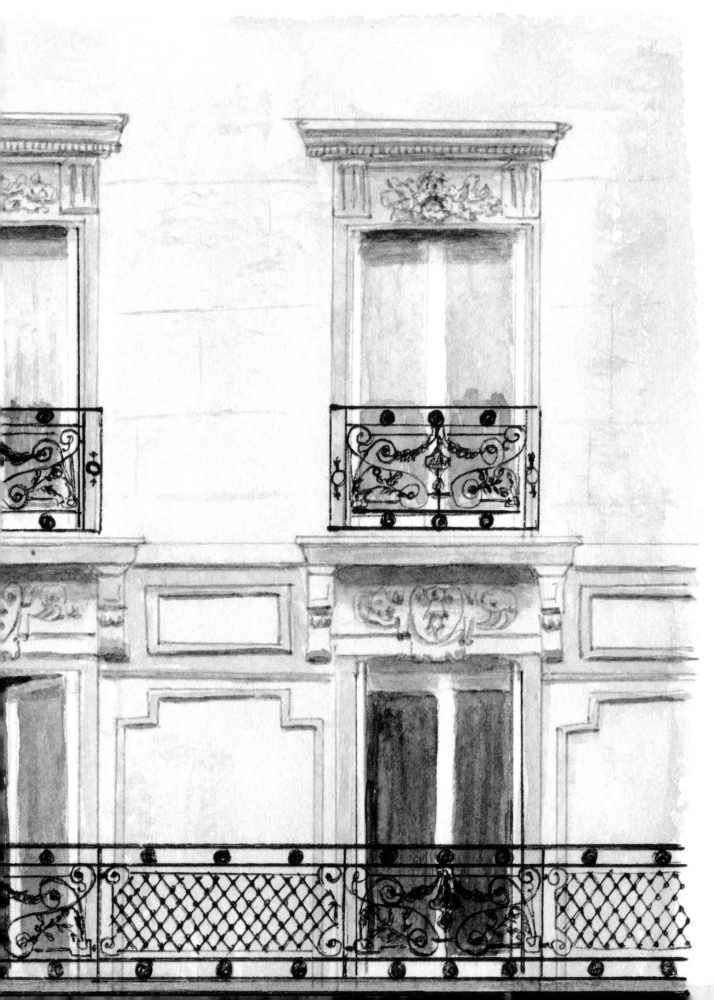

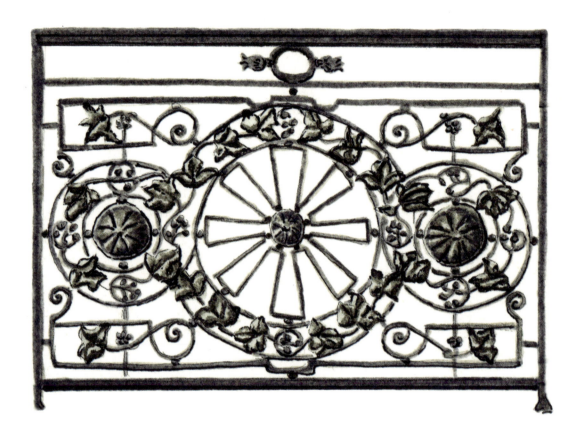

Rue de Sèvres

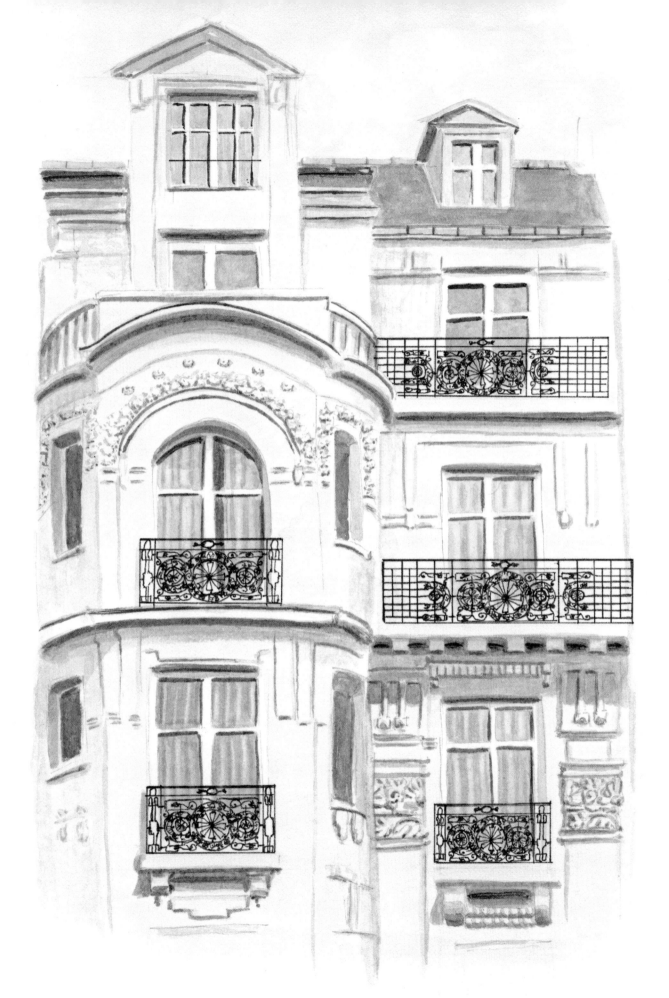

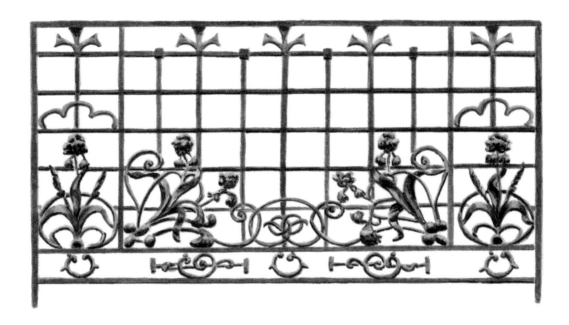

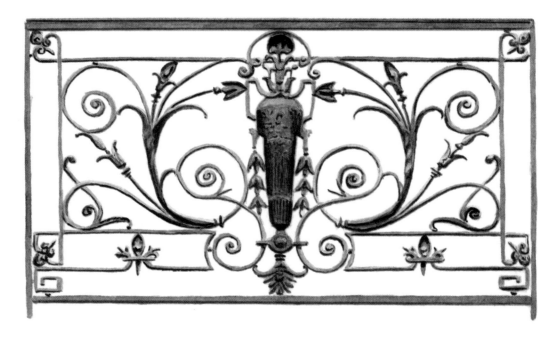

TOP AND OPPOSITE
RUE DU MONT-THABOR

BOTTOM AND FOLLOWING PAGES
RUE DE LUTÈCE

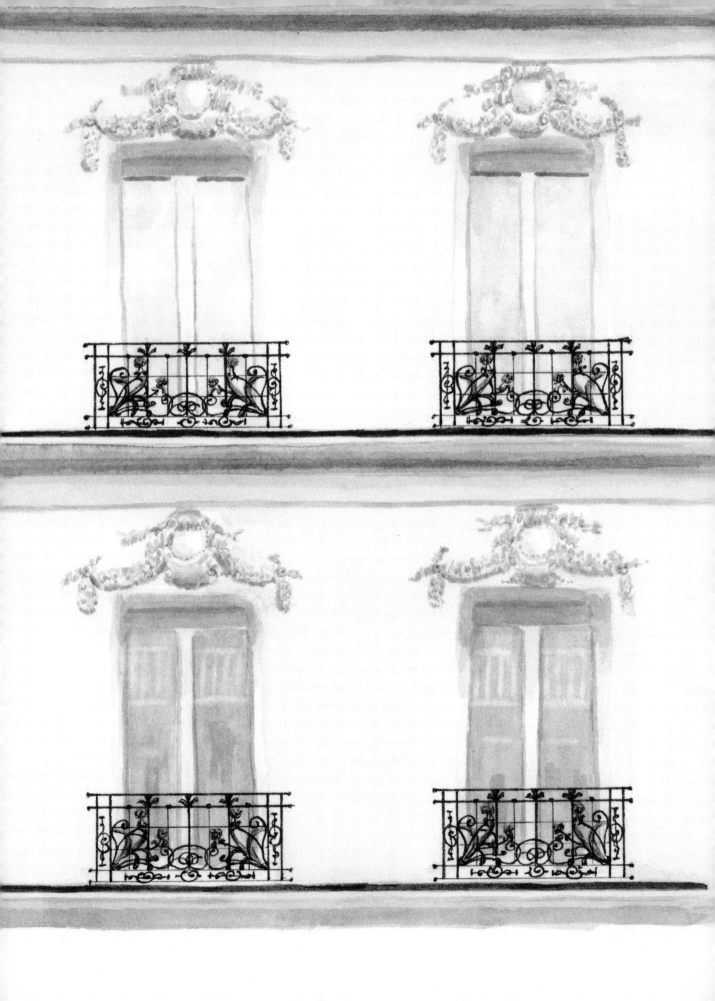

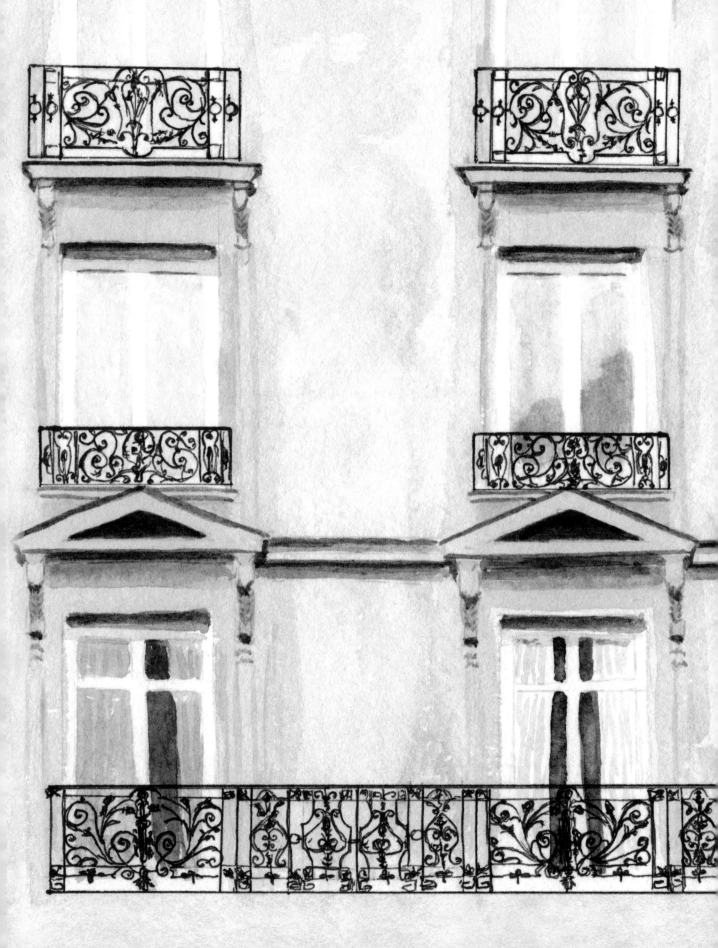

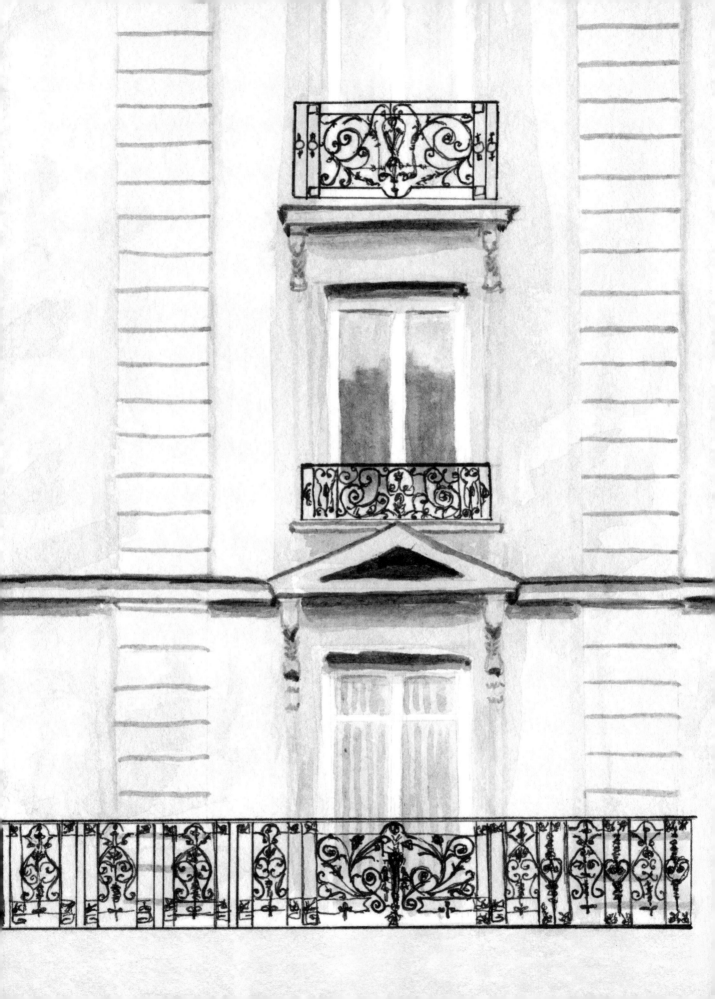

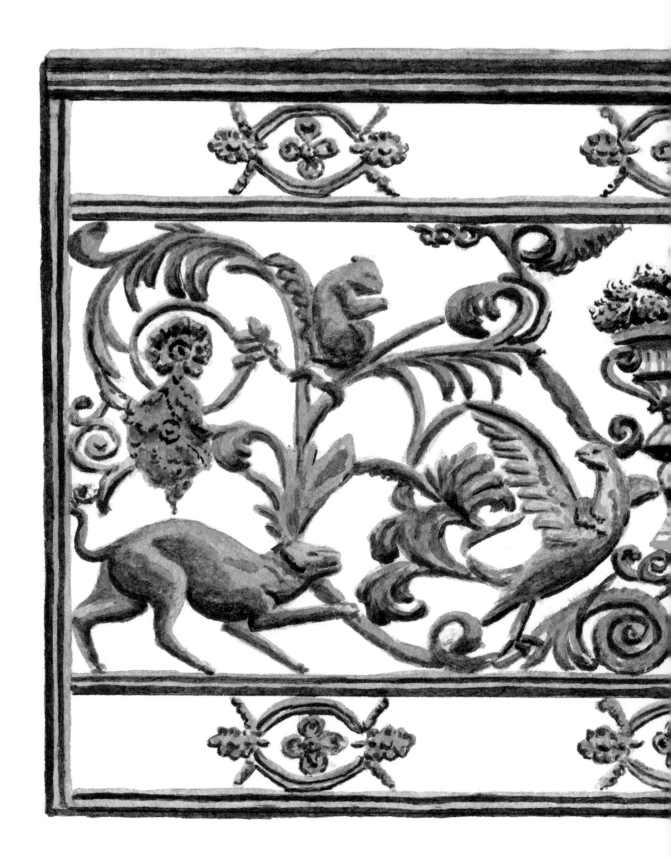

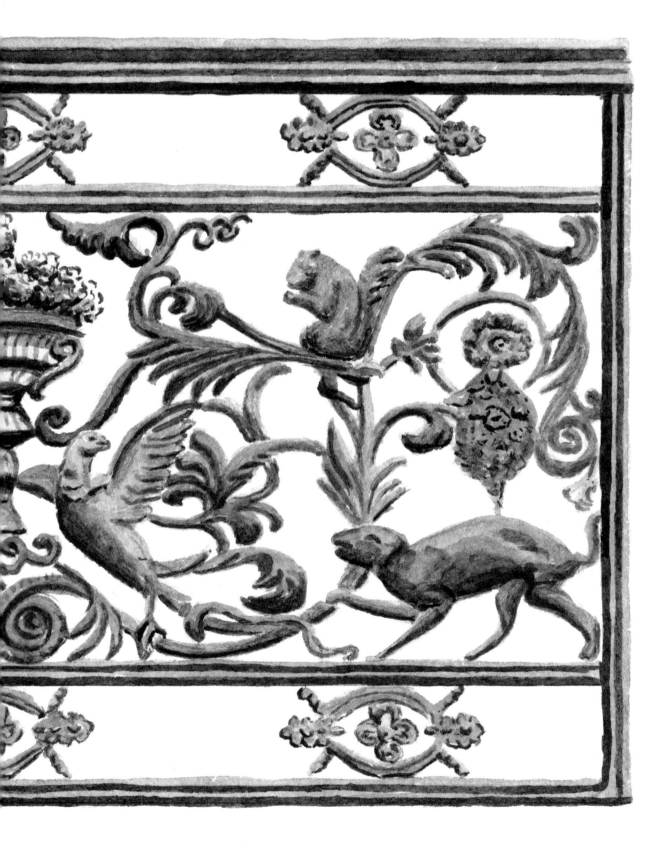

ABOVE AND FOLLOWING PAGE, LEFT
RUE SÉVIGNÉ

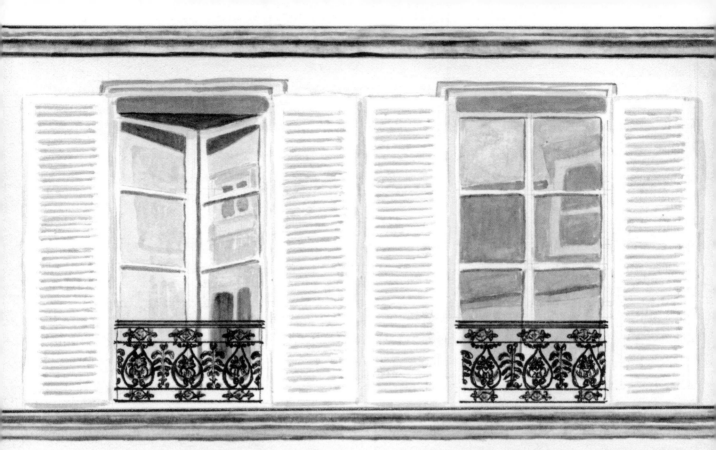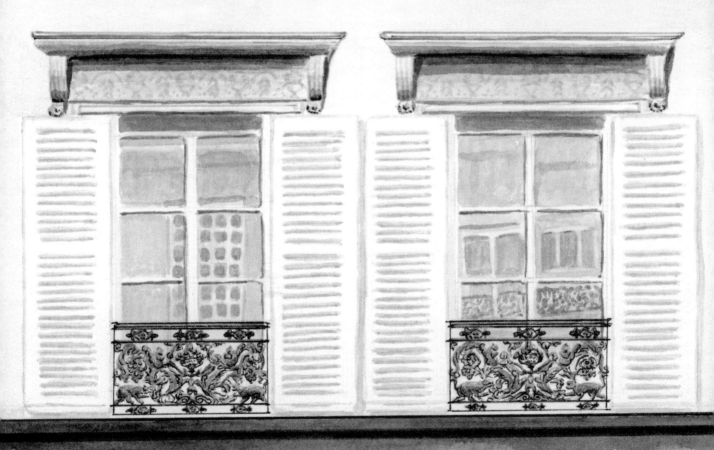

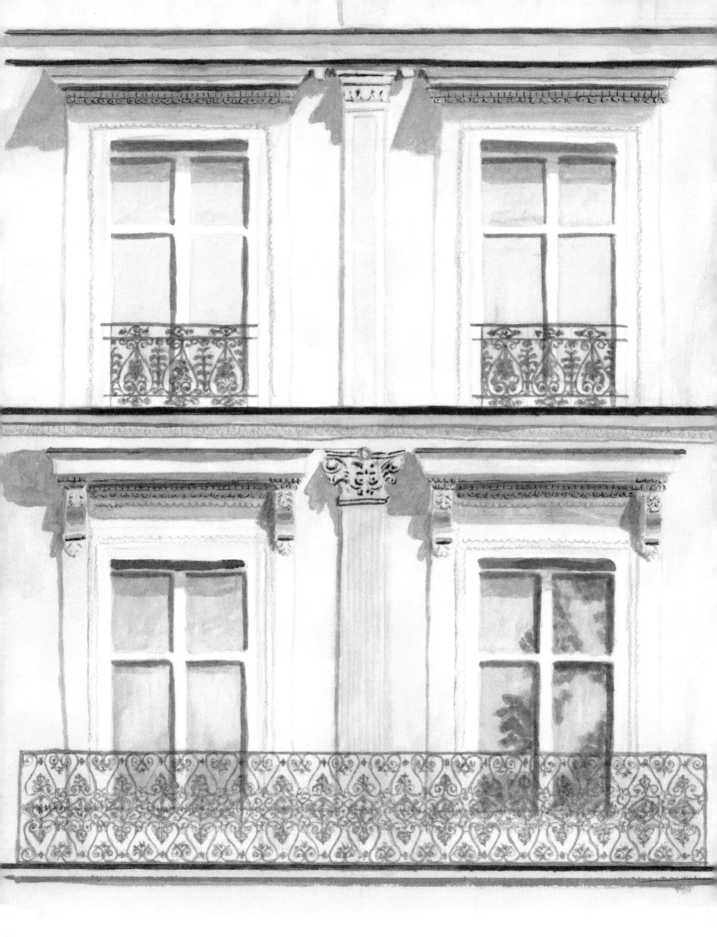

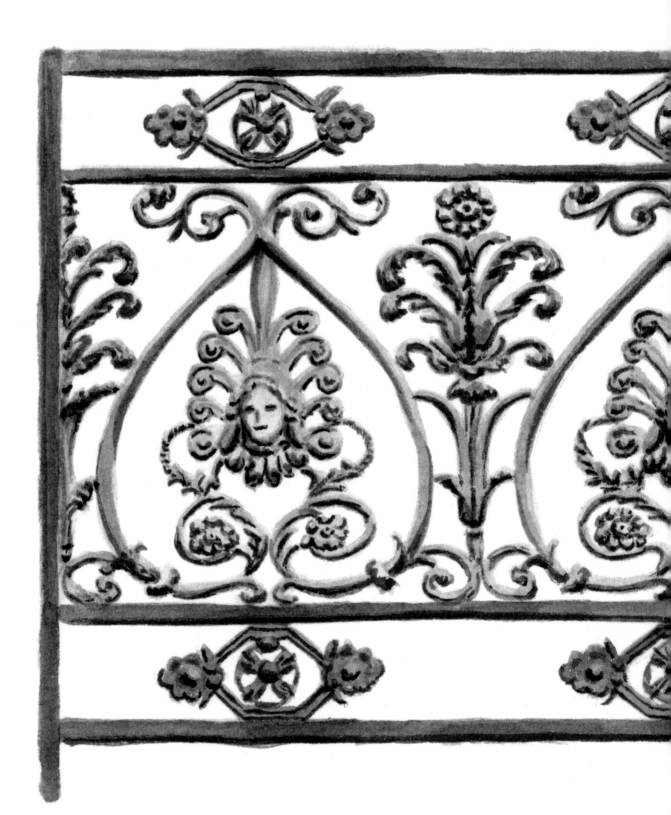

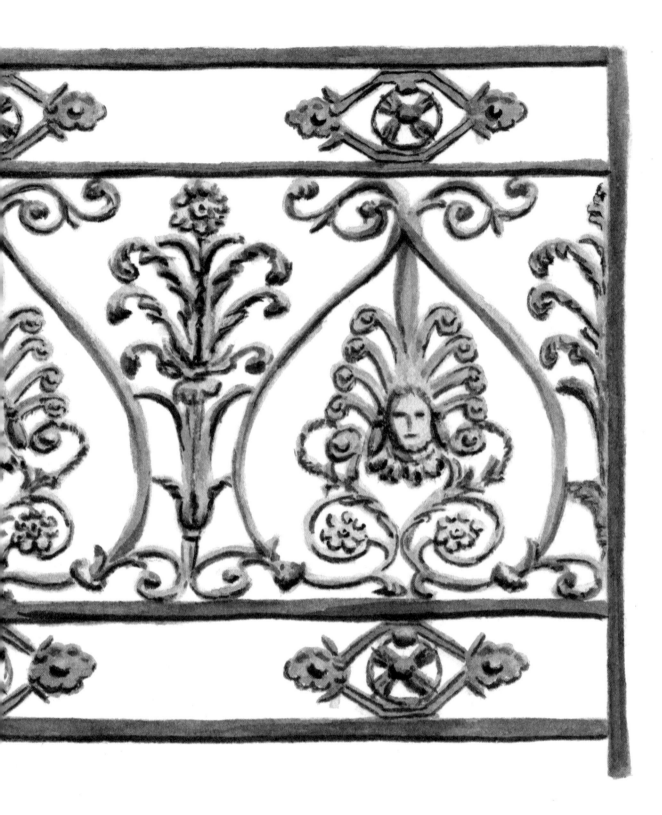

ABOVE AND PREVIOUS PAGE, RIGHT
PLACE PIERRE-KAUFFMANN

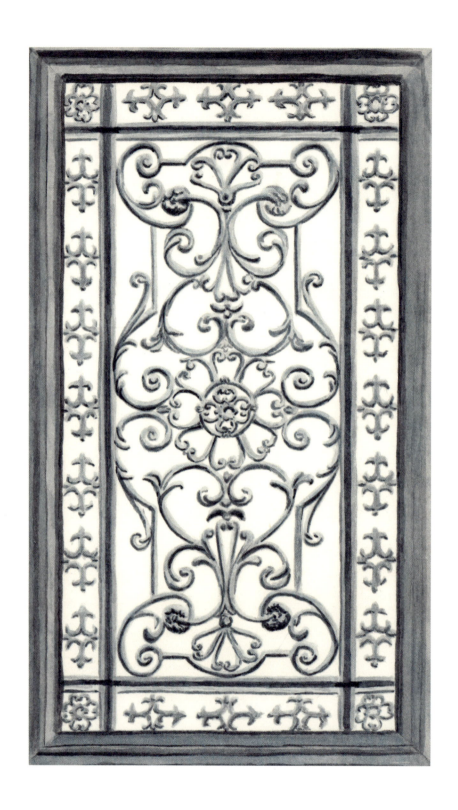

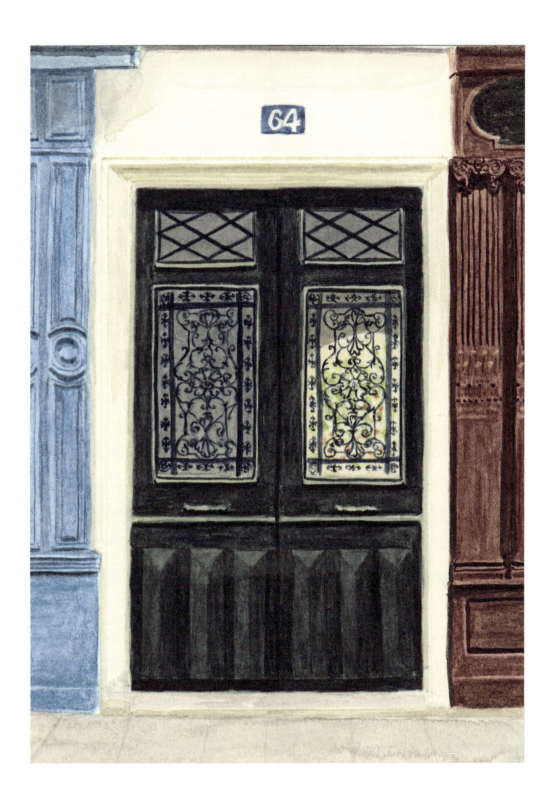

Rue Saint-Louis-en-l'Île

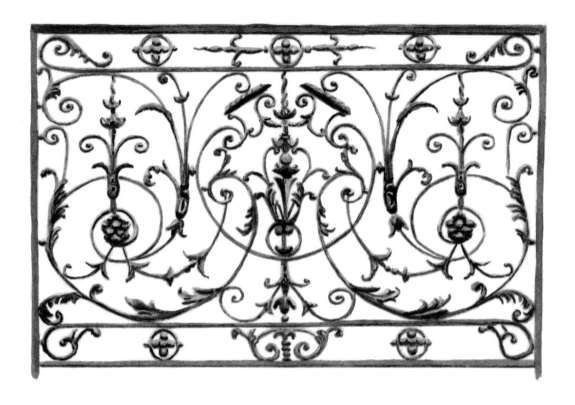
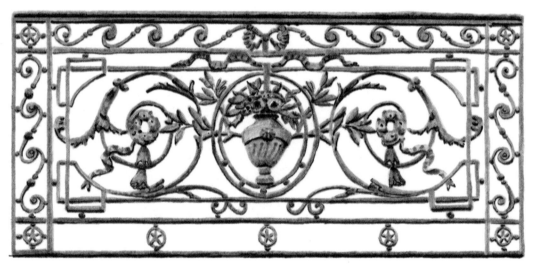

TOP
RUE DE RENNES

BOTTOM
AVENUE GEORGE-V

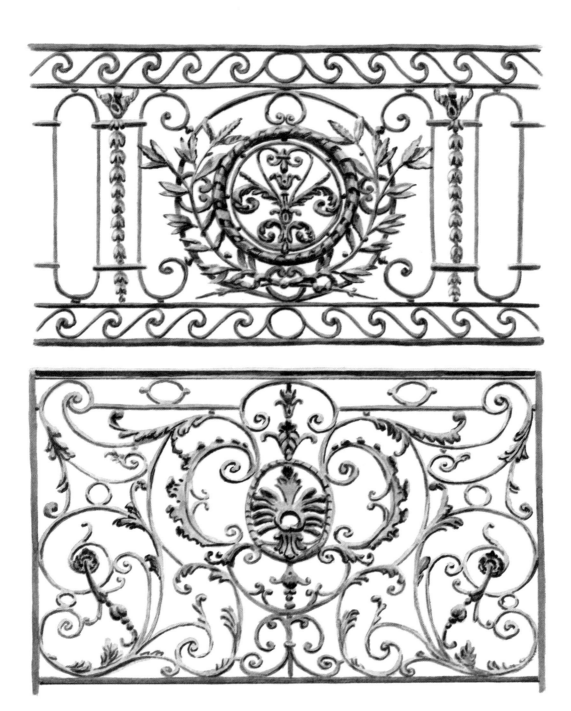

TOP
BOULEVARD DU MONTPARNASSE

BOTTOM
RUE DE LA PÉPINIÈRE

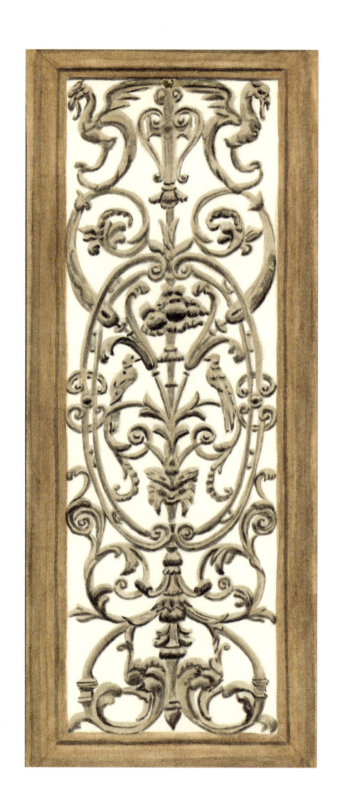

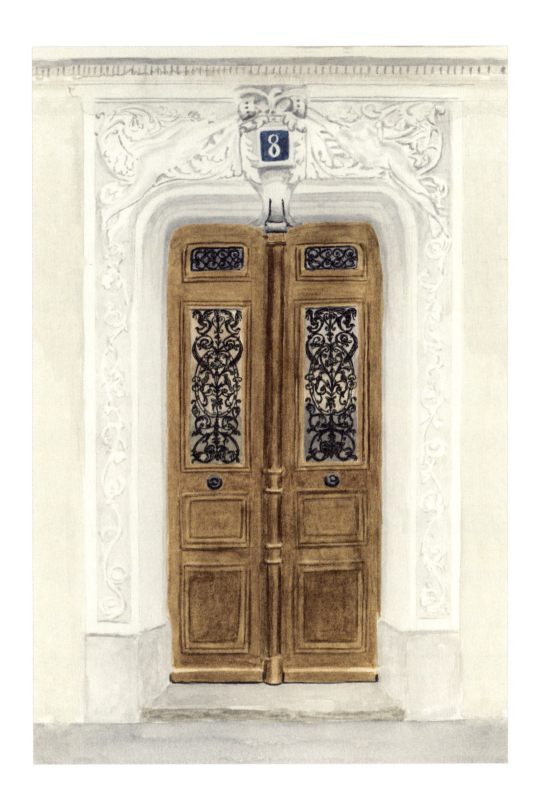

Boulevard des Filles-du-Calvaire

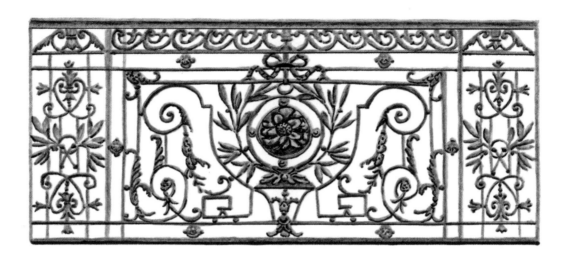

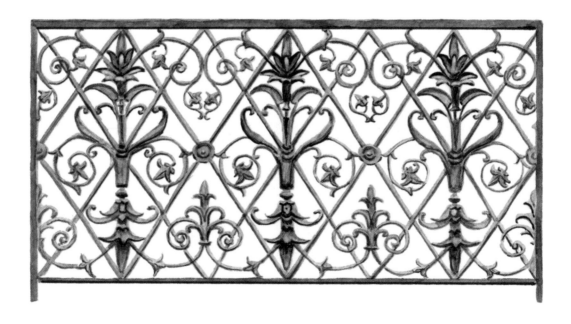

TOP AND OPPOSITE
AVENUE DU PRÉSIDENT-WILSON

BOTTOM AND FOLLOWING PAGES
BOULEVARD SAINT-MICHEL

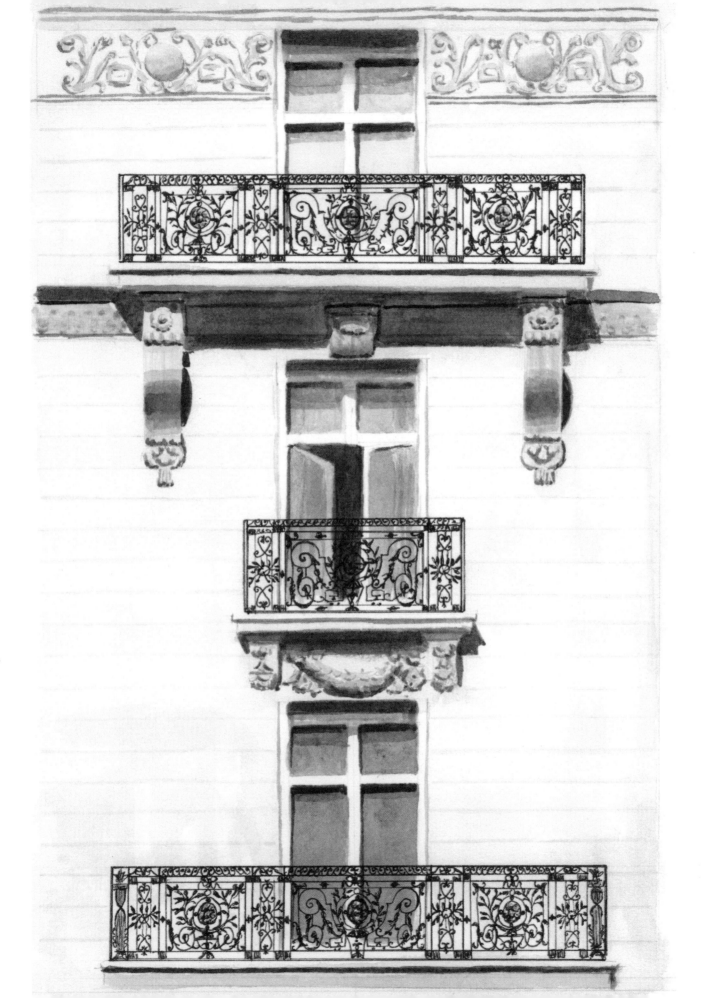

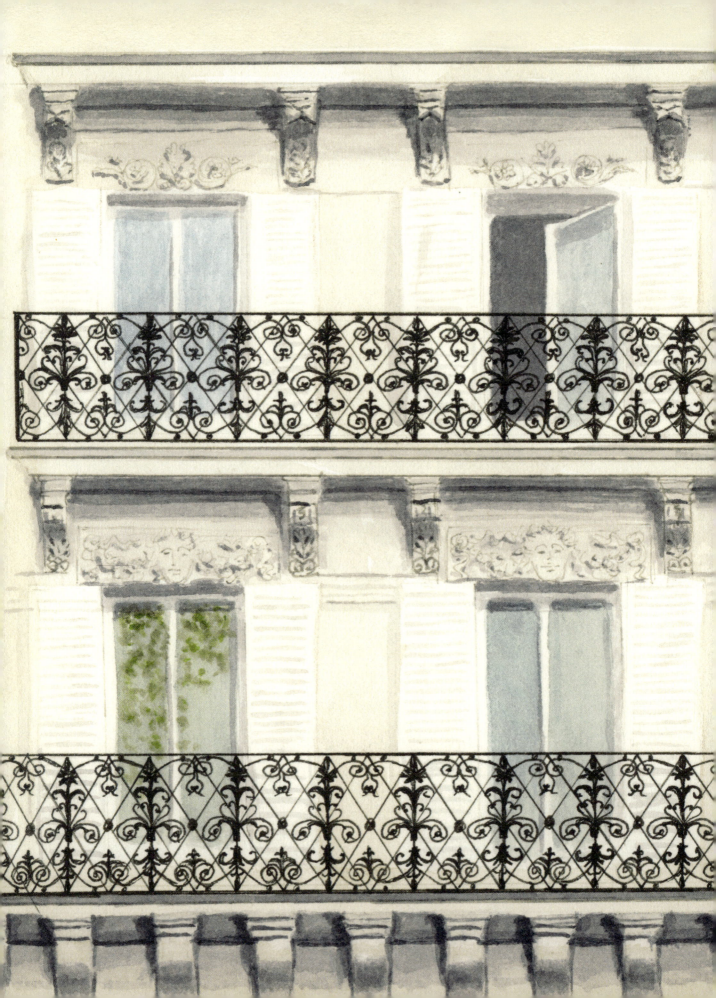

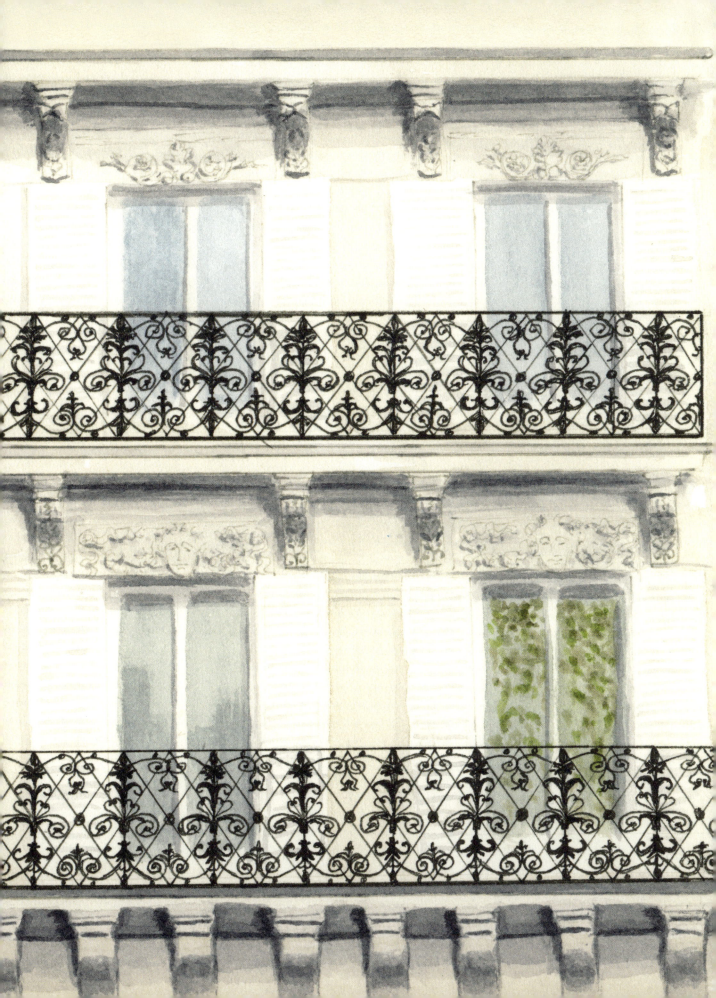

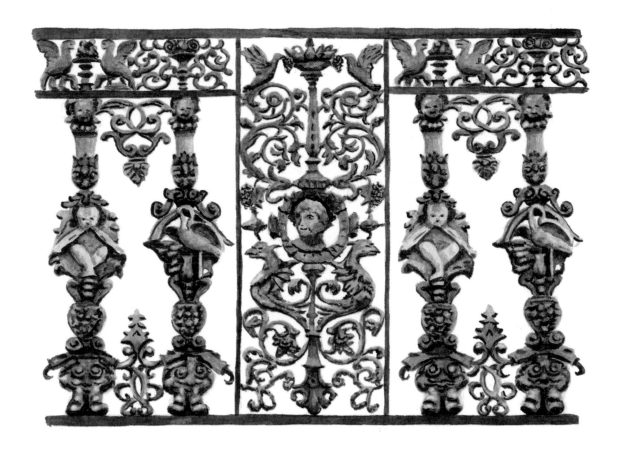

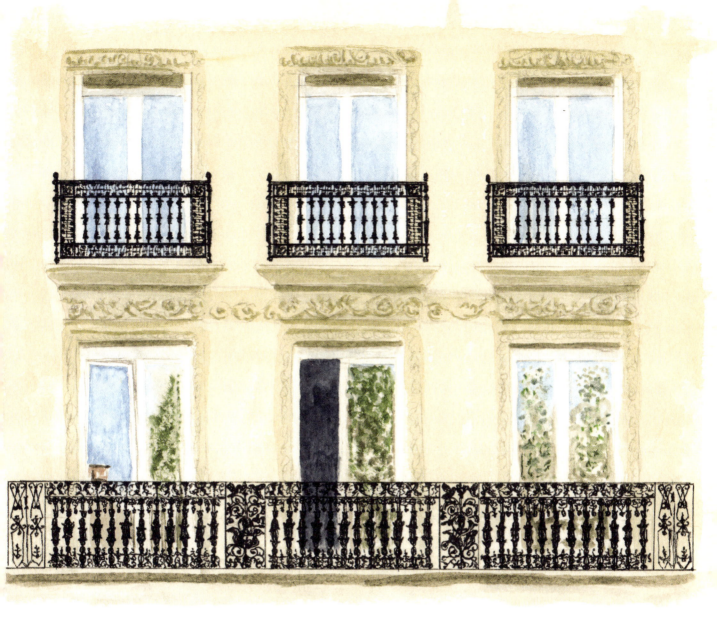

Boulevard Saint-Martin

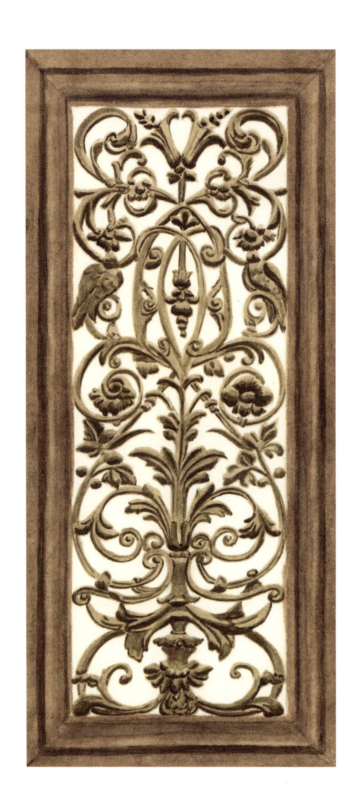

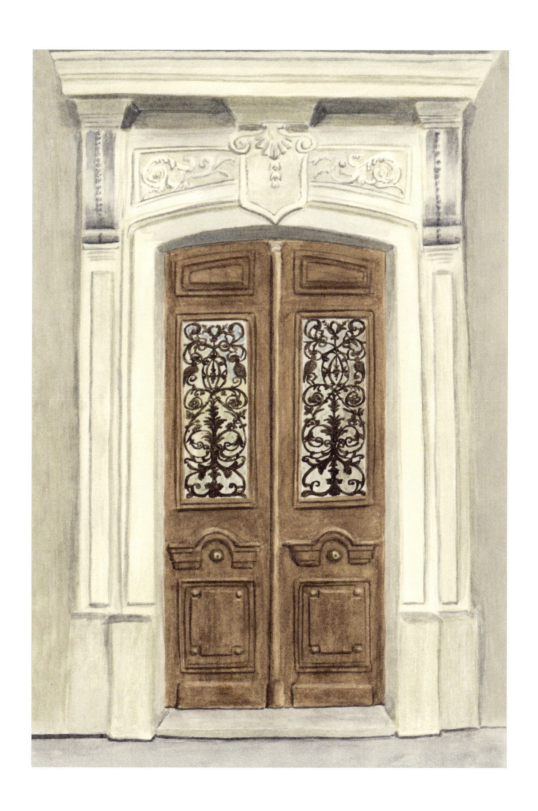

Avenue Parmentier

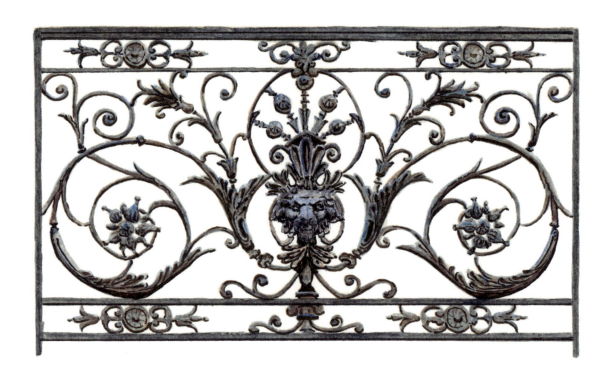

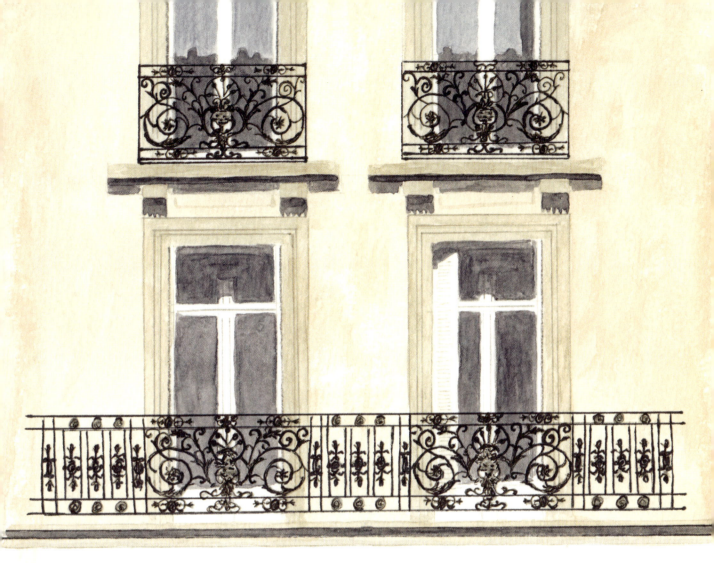

Rue de Rennes

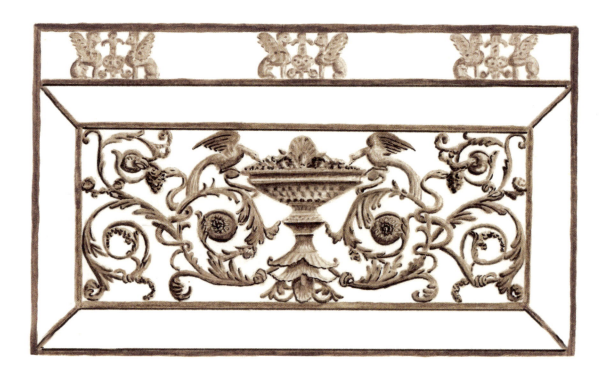

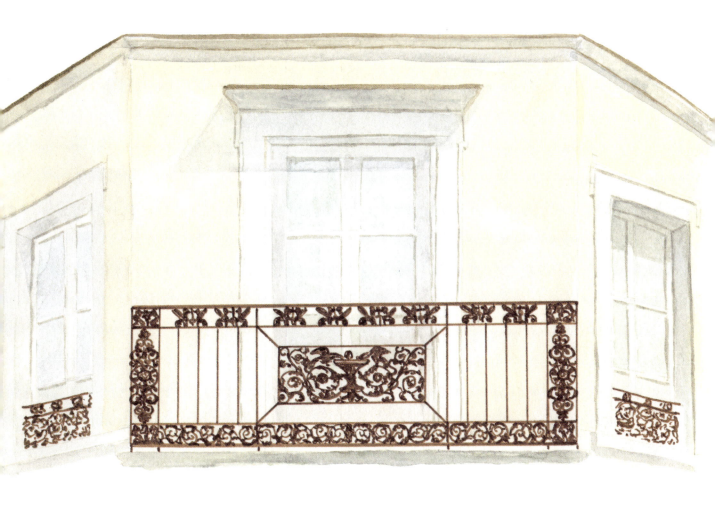

Rue du Pont-Louis-Philippe

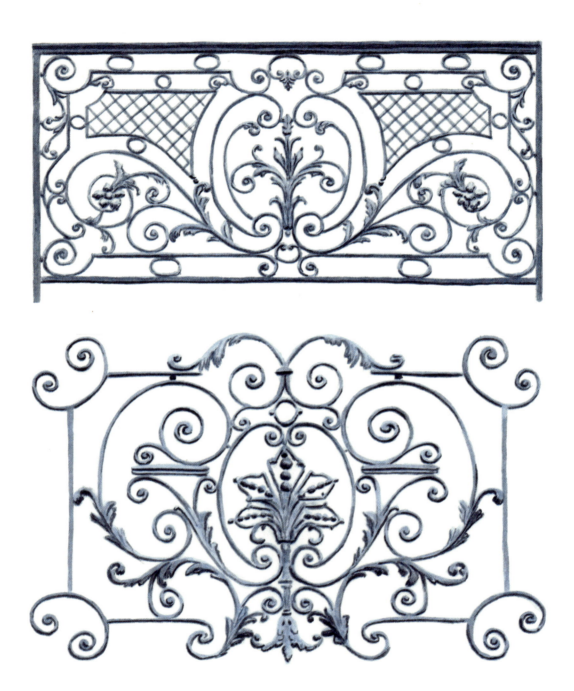

ABOVE AND OPPOSITE
PLACE MICHEL-DEBRÉ

FOLLOWING PAGES
BOULEVARD SAINT-MICHEL

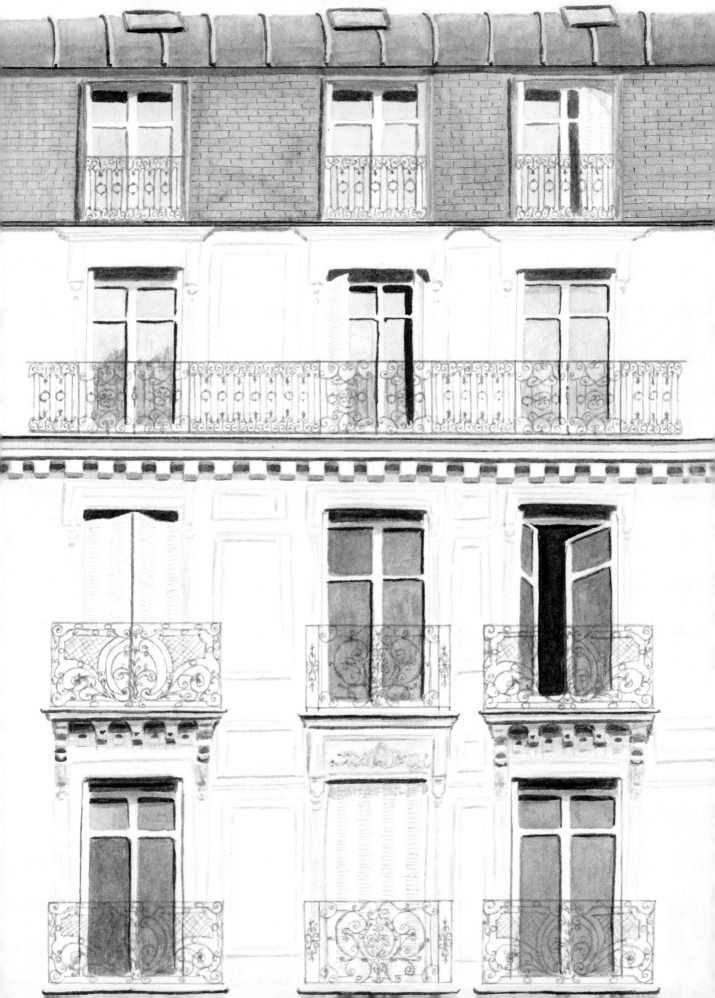

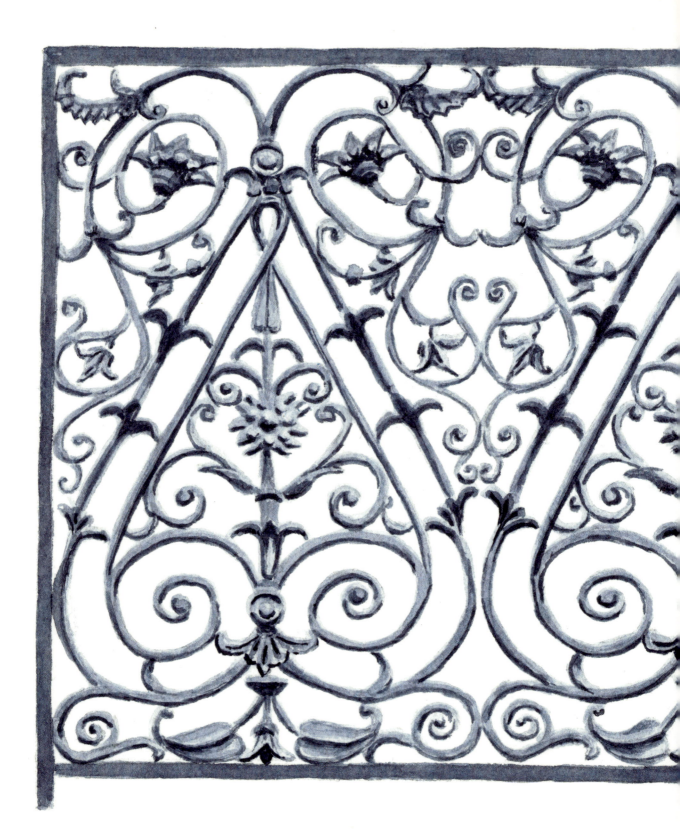

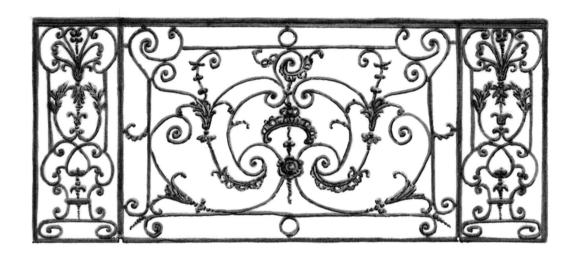

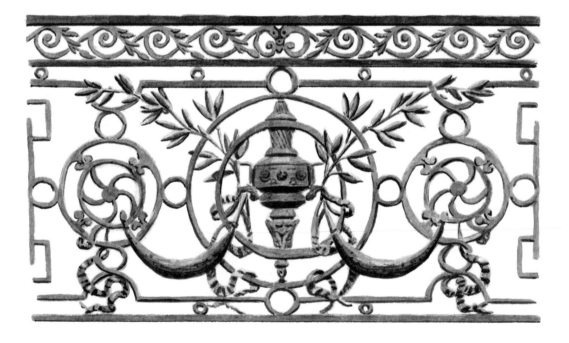

TOP AND OPPOSITE
RUE DE SOLFÉRINO

BOTTOM AND FOLLOWING PAGES
BOULEVARD SAINT-GERMAIN

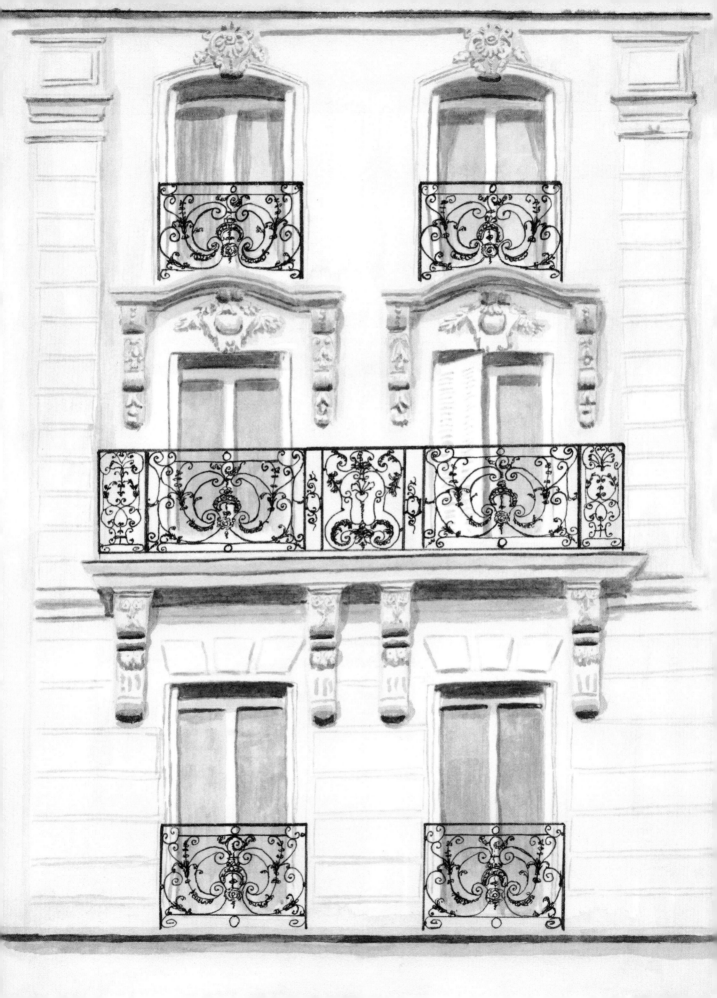

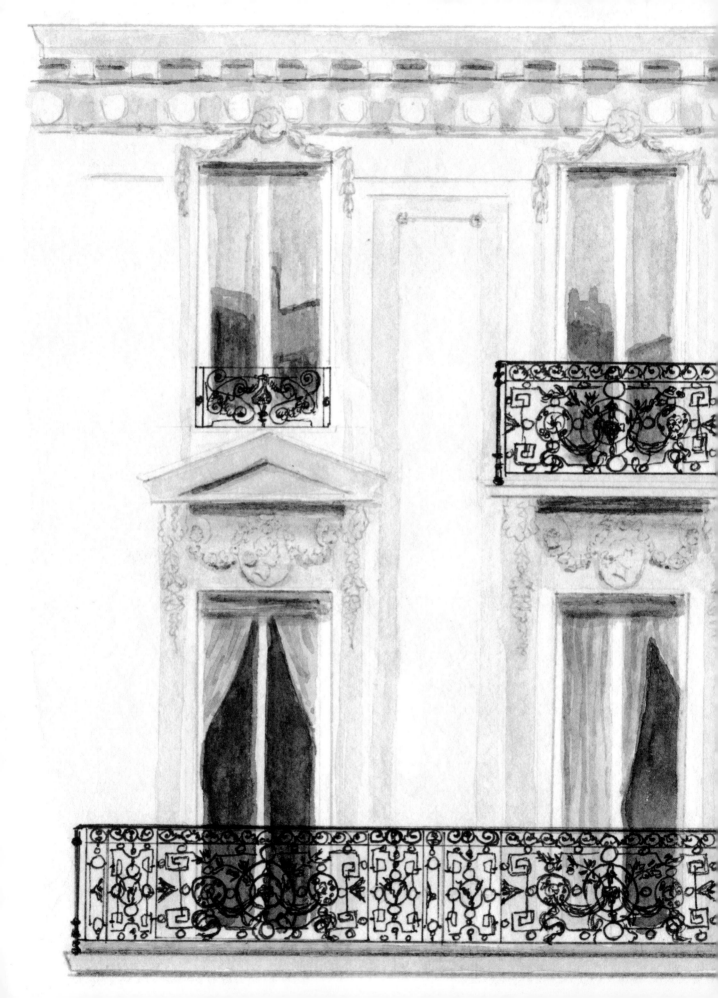

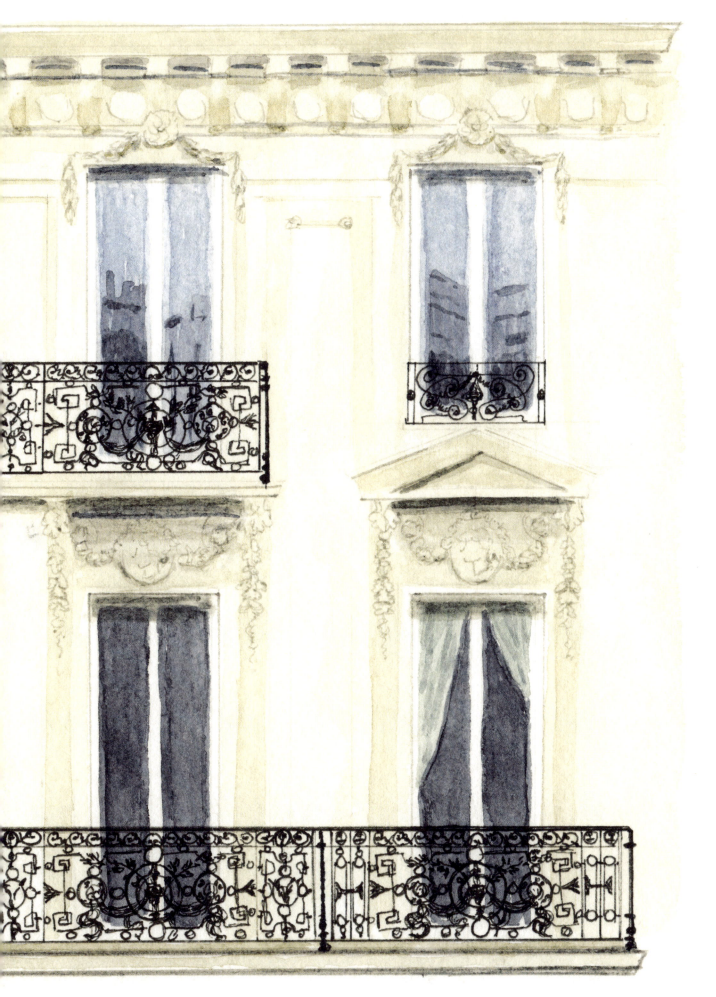

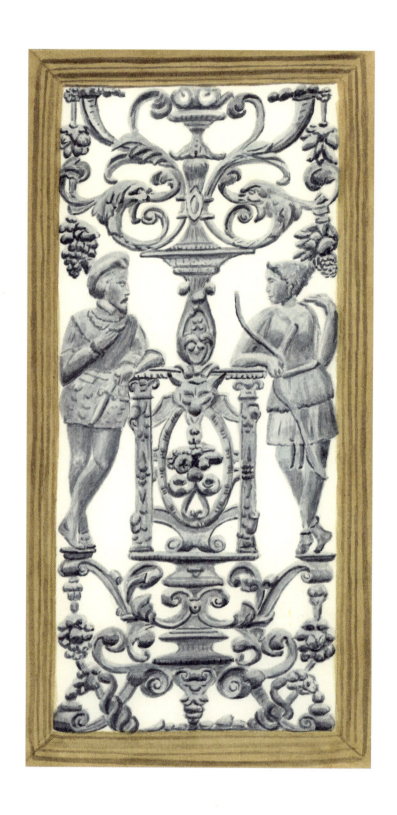

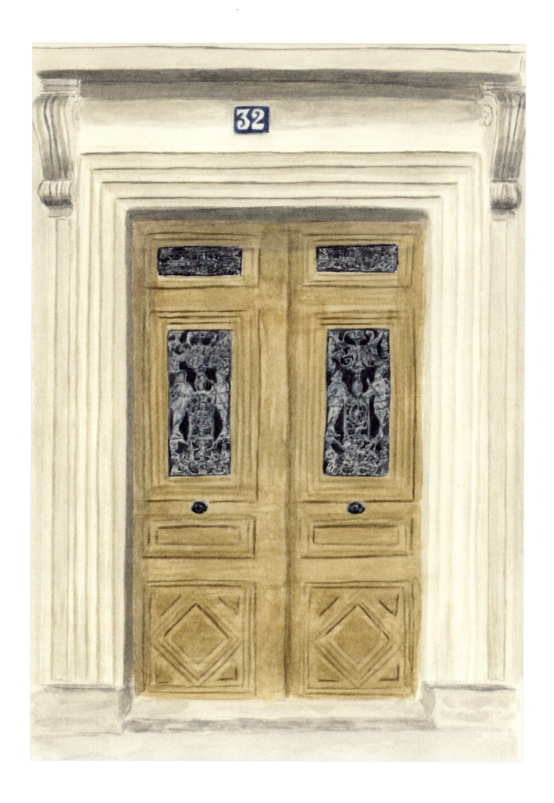

Rue de Rivoli

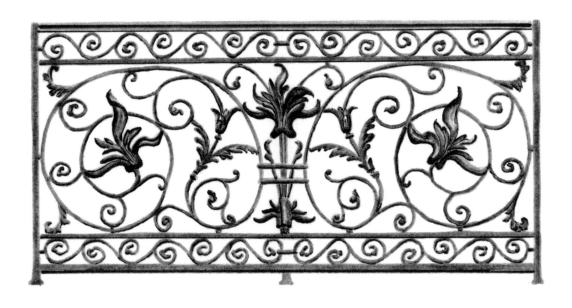
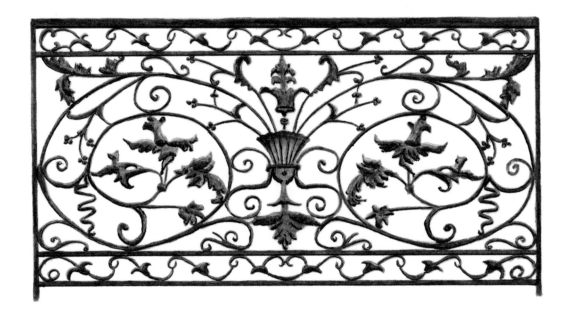

TOP
RUE DE SÈVRES

BOTTOM
BOULEVARD RASPAIL

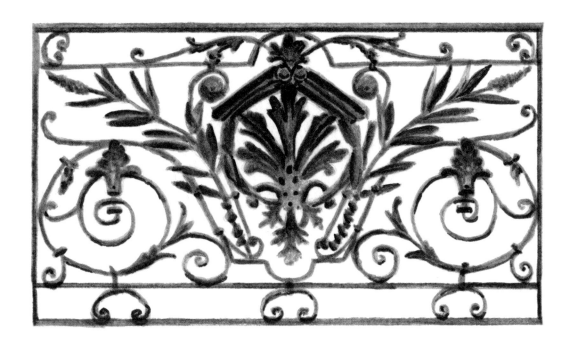

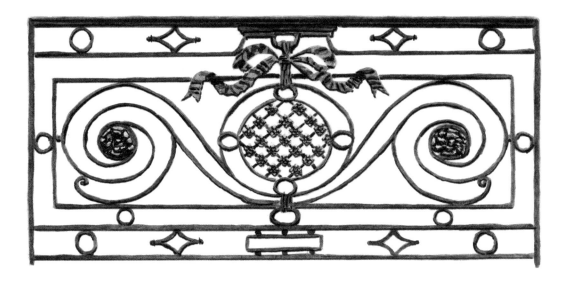

TOP
AVENUE MONTAIGNE

BOTTOM
RUE DE SOLFÉRINO

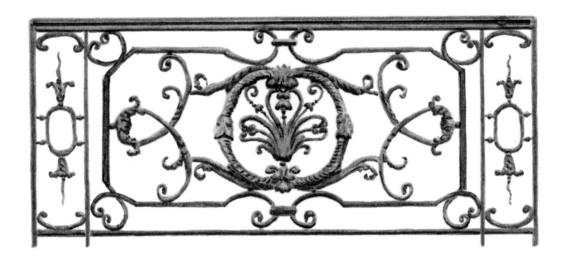

TOP AND OPPOSITE
AVENUE MARCEAU

BOTTOM AND FOLLOWING PAGES
RUE DE RENNES

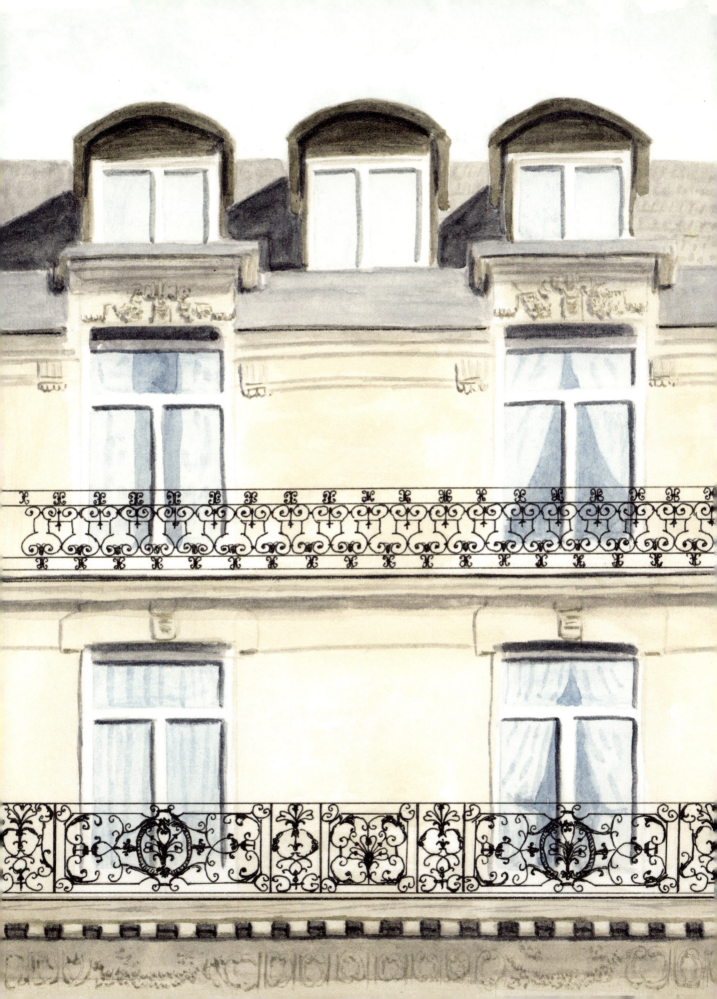

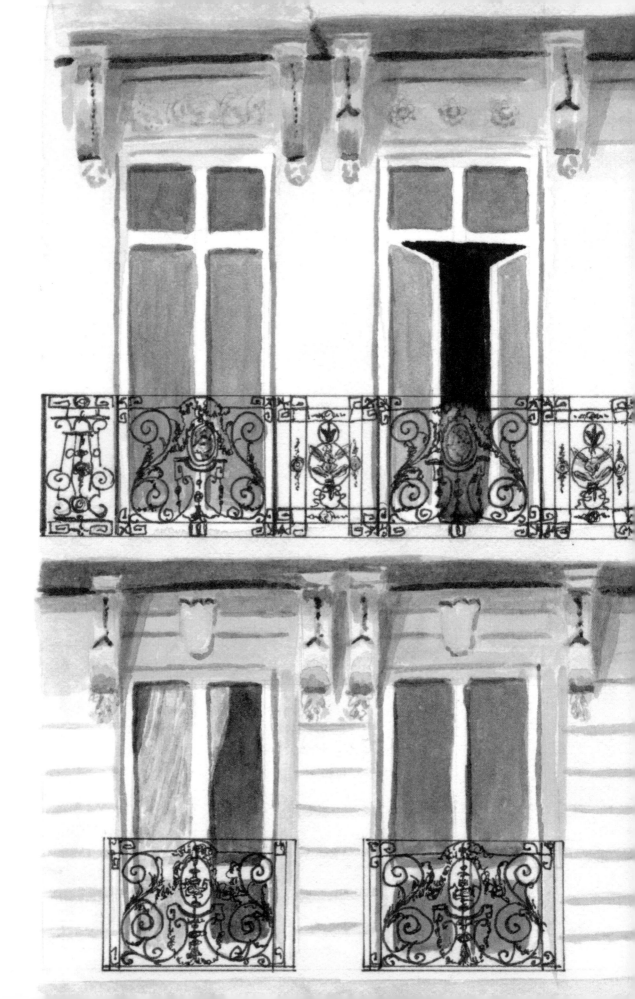

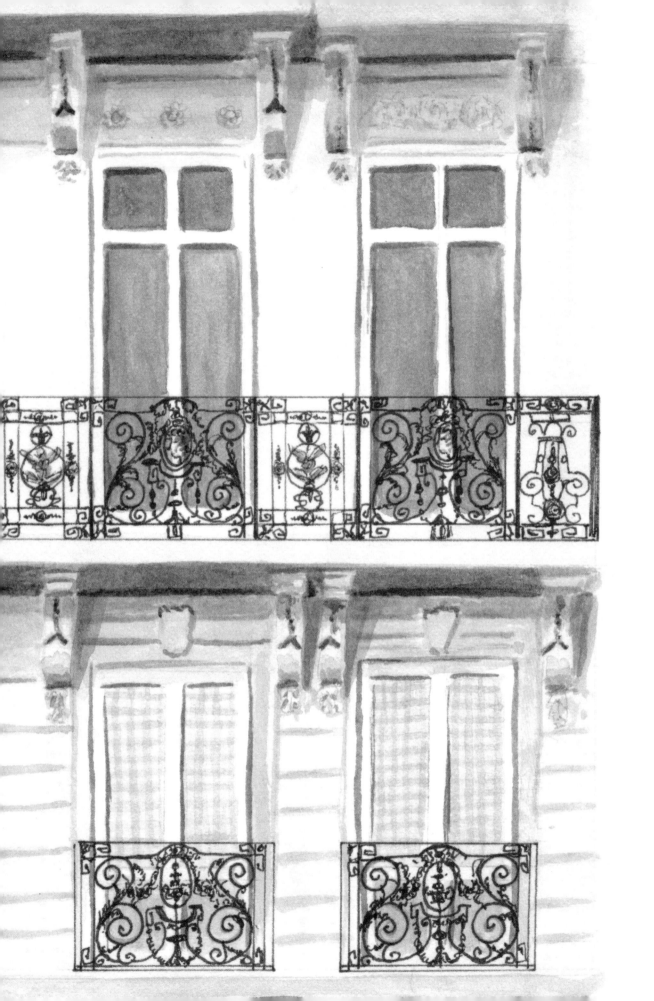

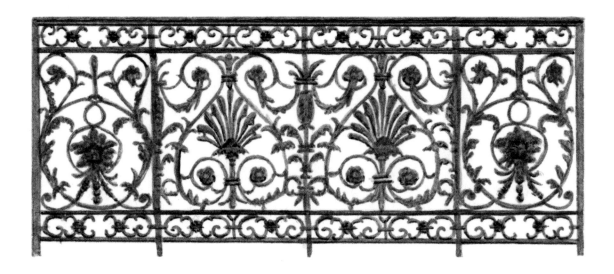

ABOVE, OPPOSITE,
AND FOLLOWING PAGES
RUE DANTON

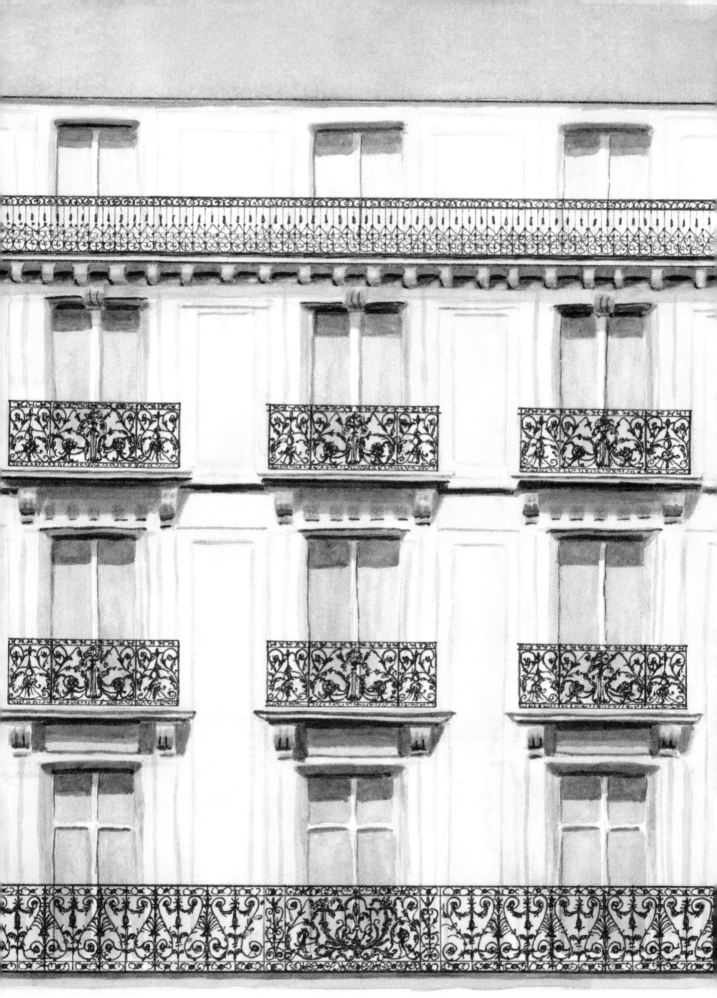

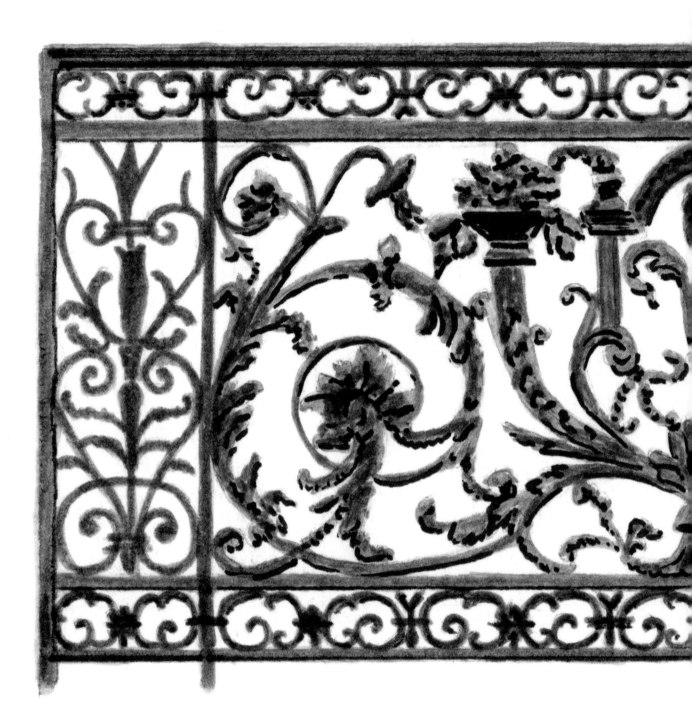

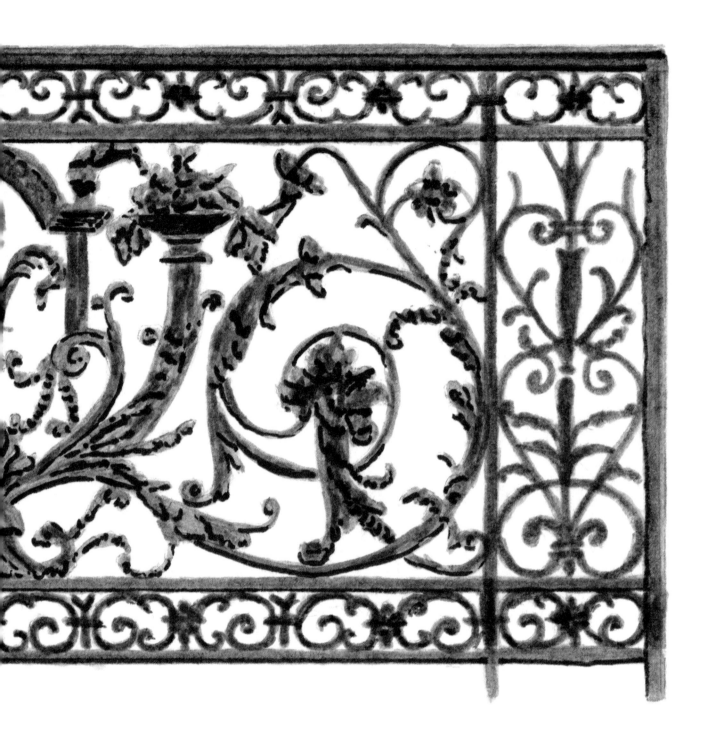

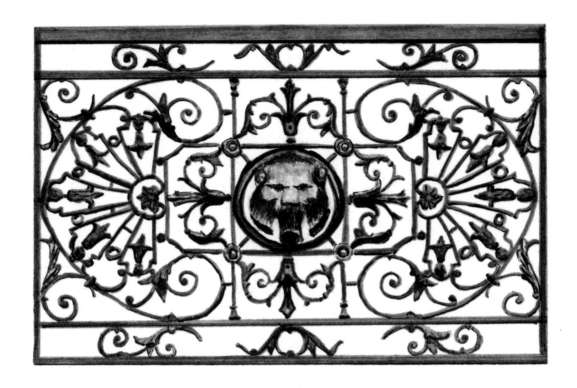

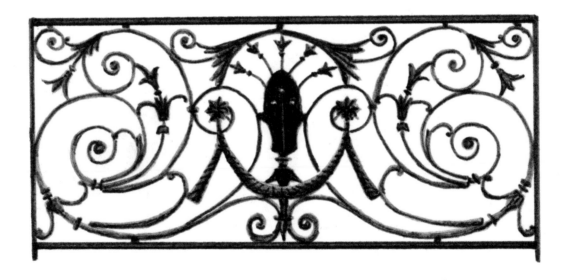

TOP AND OPPOSITE
RUE DU BOCCADOR

BOTTOM AND FOLLOWING PAGES
QUAI AUX FLEURS

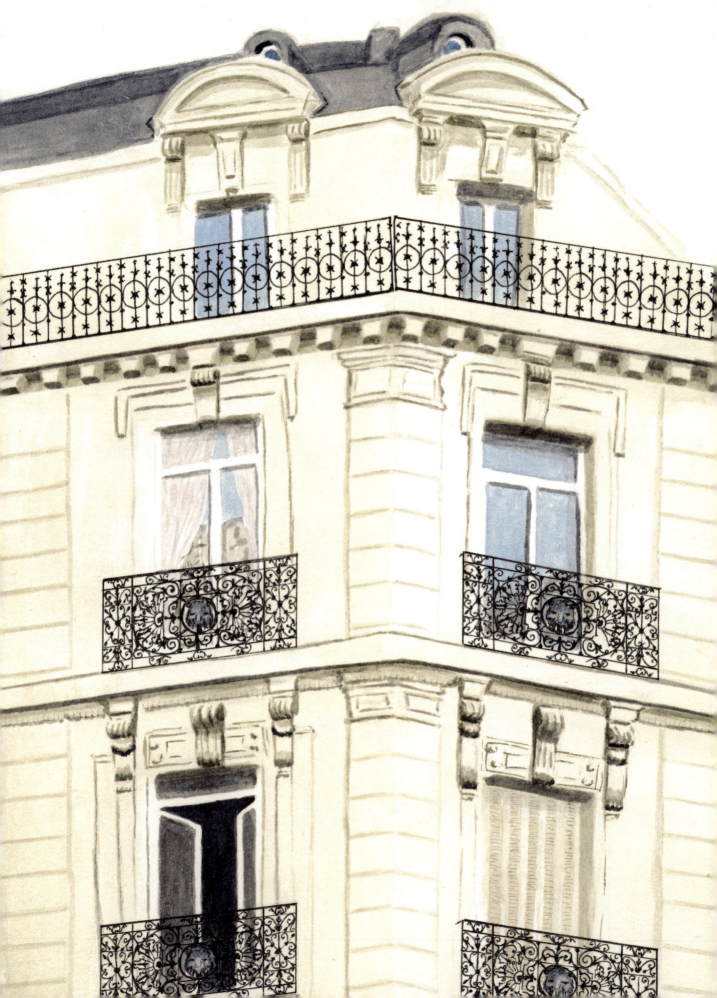

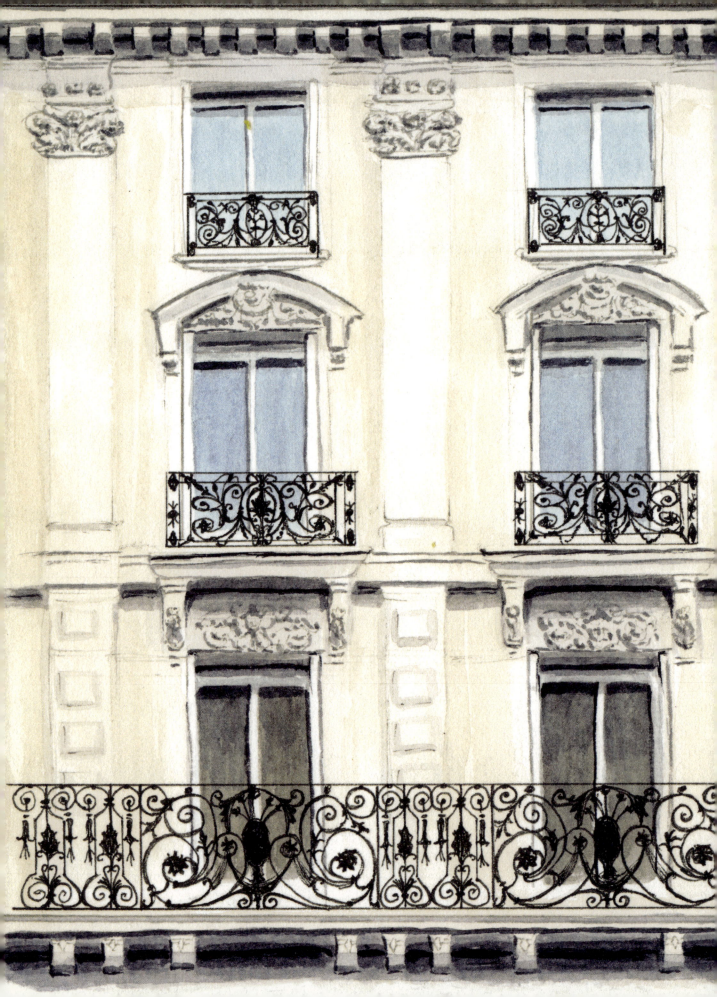

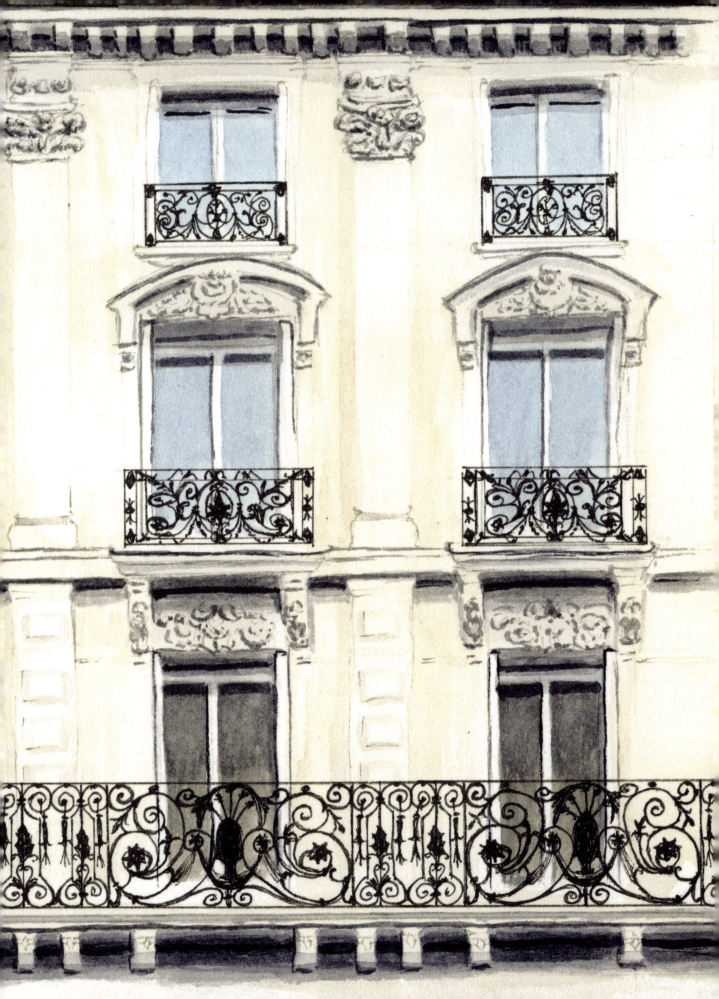

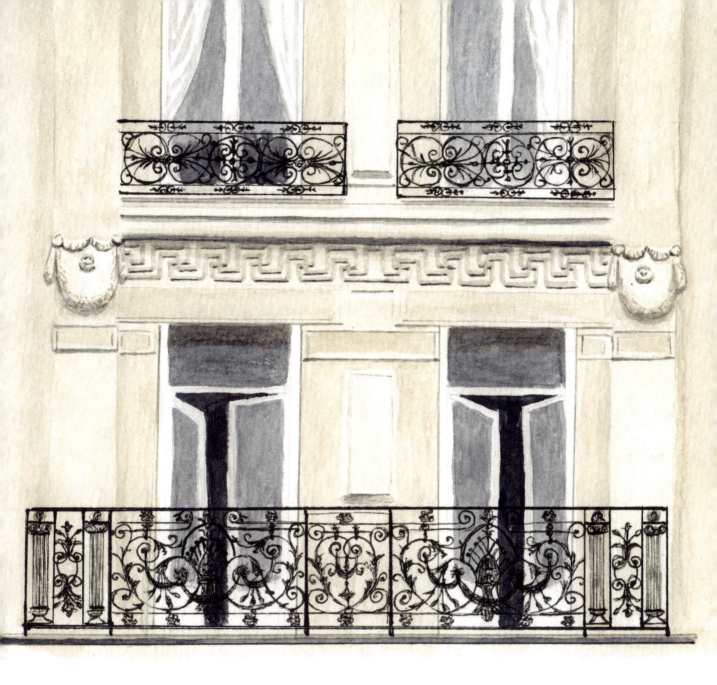

OPPOSITE AND ABOVE
RUE DE RENNES

FOLLOWING PAGES
RUE DES ARCHIVES

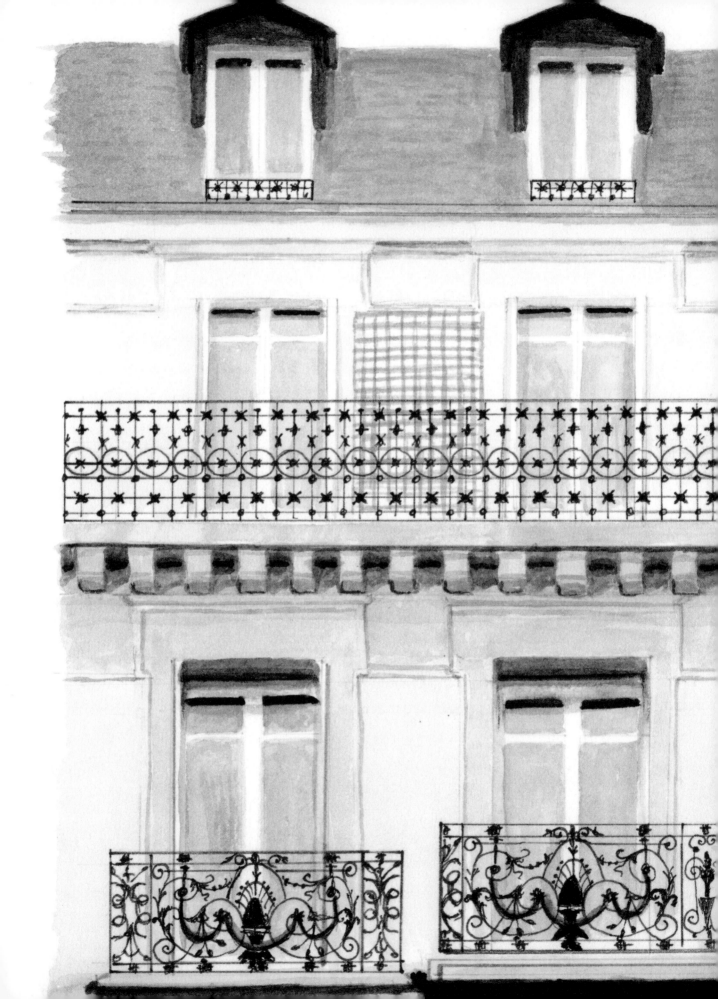

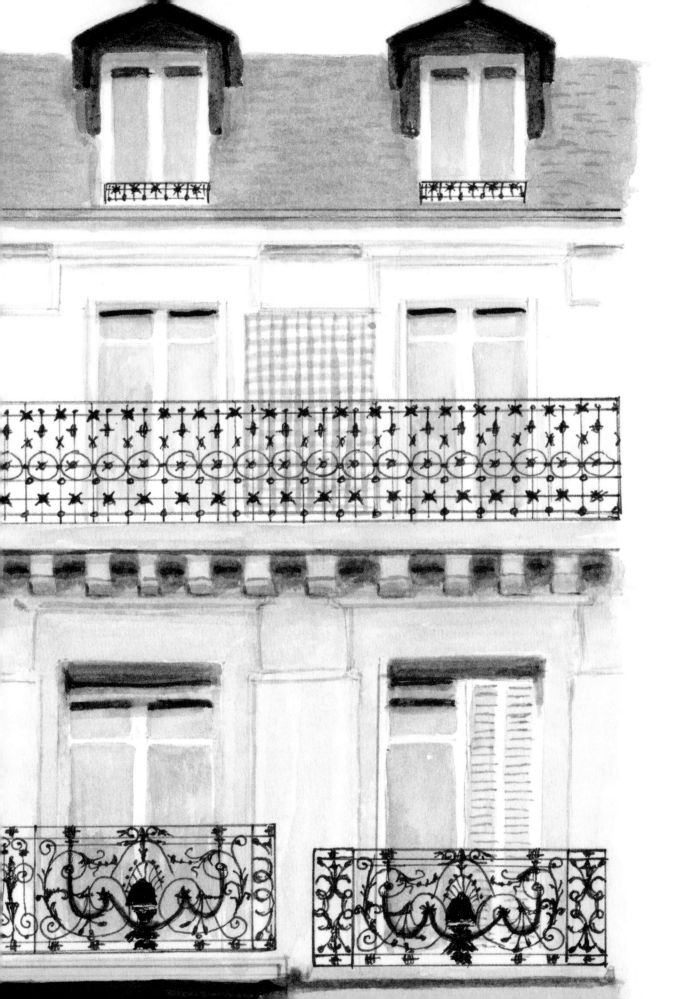

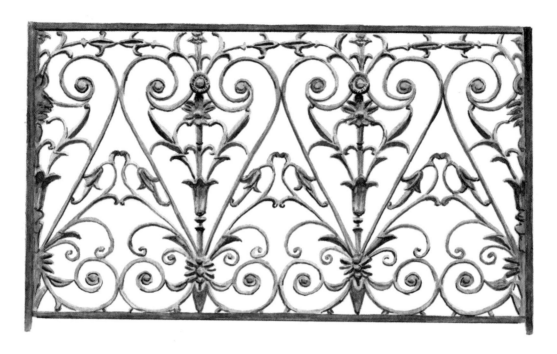

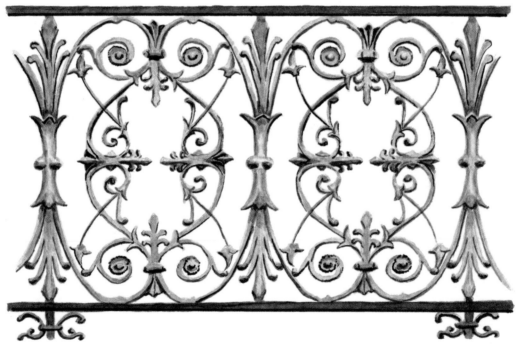

TOP
QUAI SAINT-MICHEL

BOTTOM
RUE DE RIVOLI

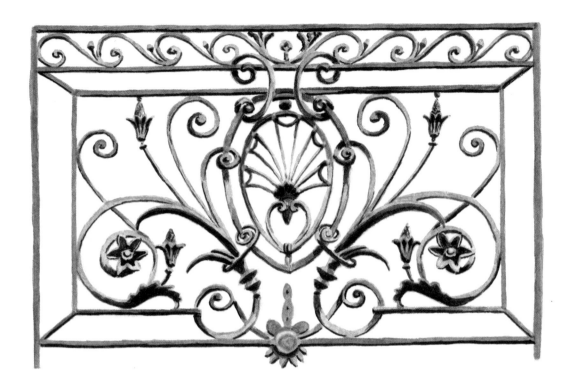

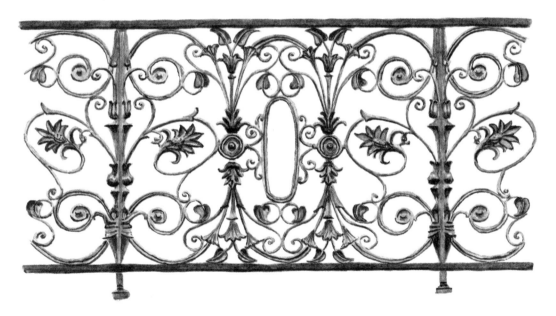

TOP
BOULEVARD HAUSSMANN

BOTTOM
RUE AUX OURS

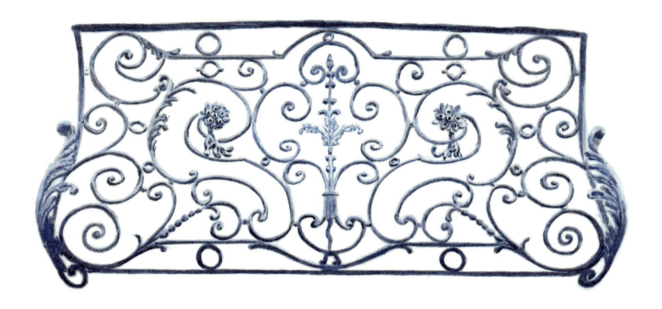

Rue du Regard

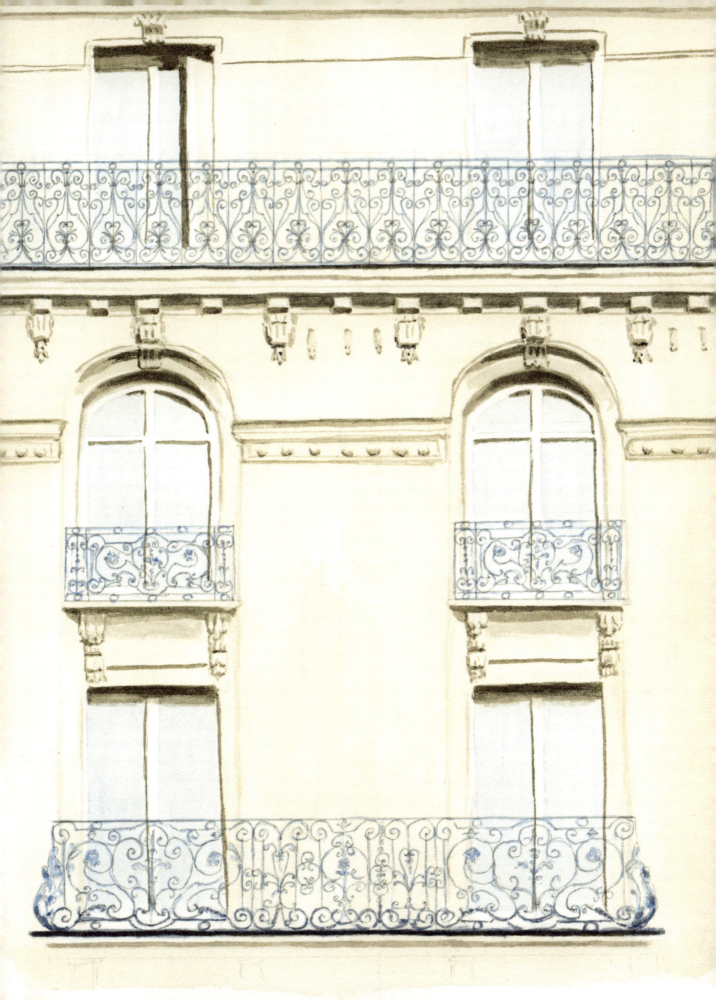

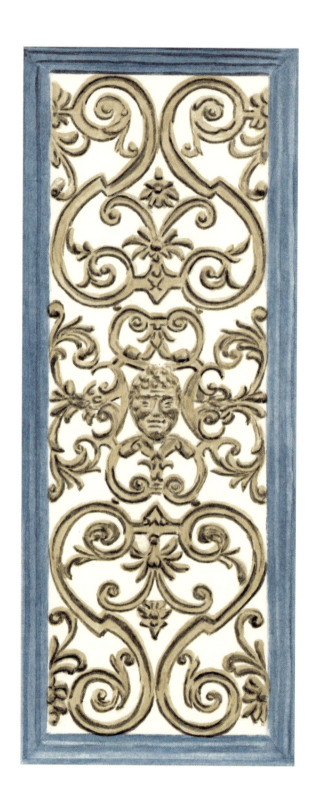

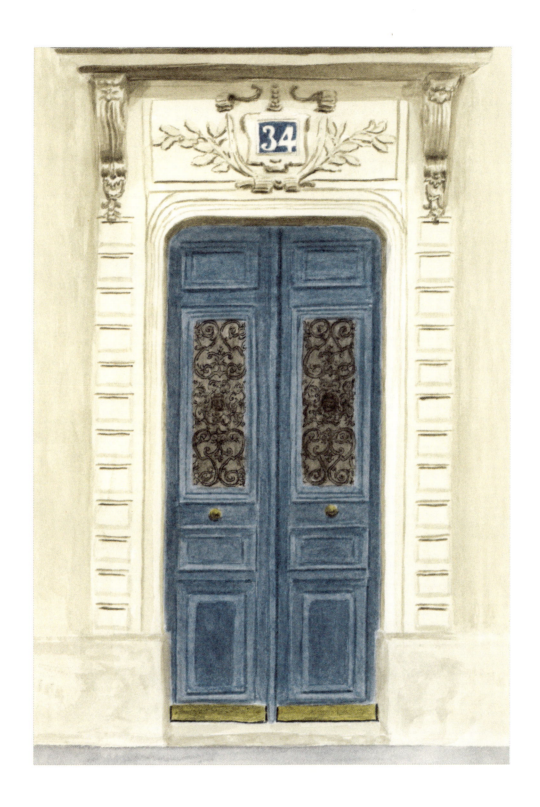

Rue Saint-Sébastien

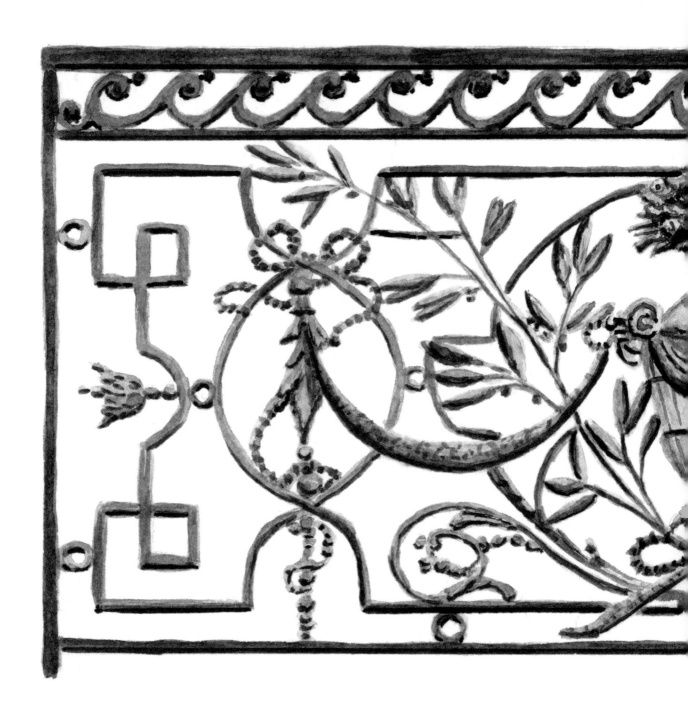

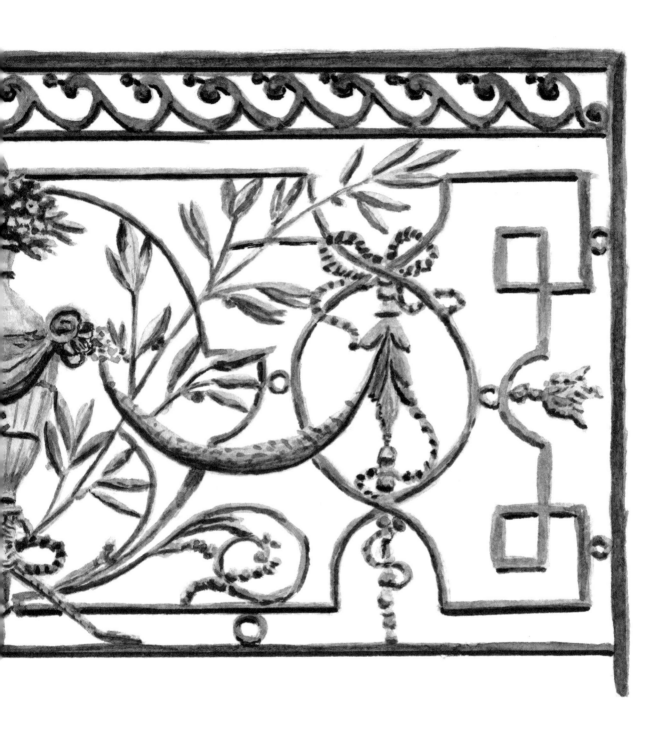

ABOVE AND FOLLOWING PAGES
BOULEVARD SAINT-GERMAIN

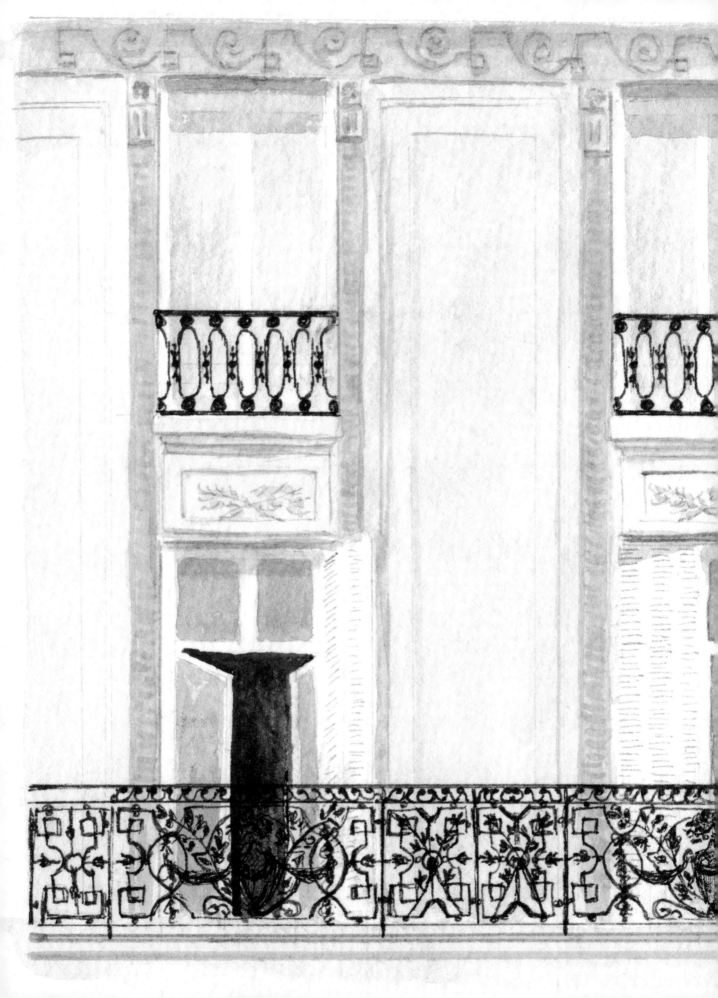

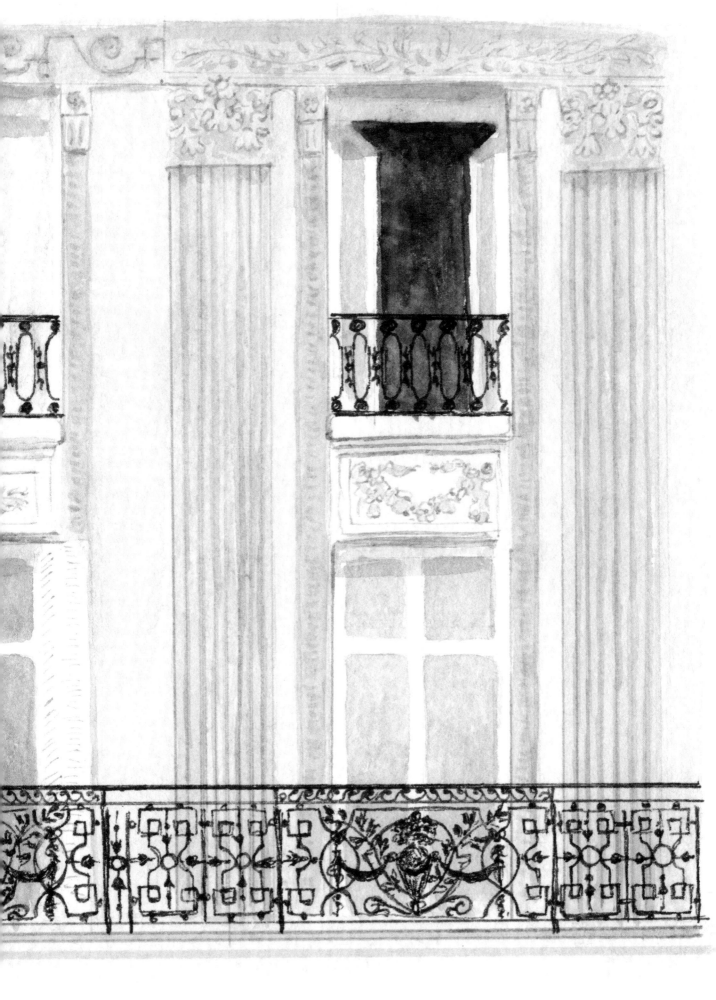

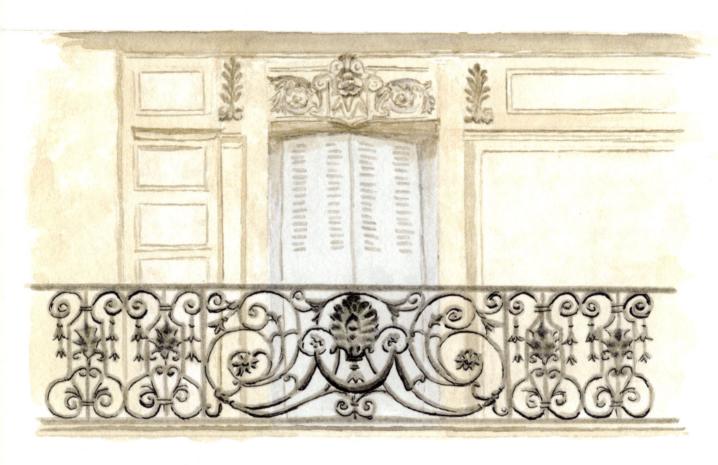

Rue d'Arcole

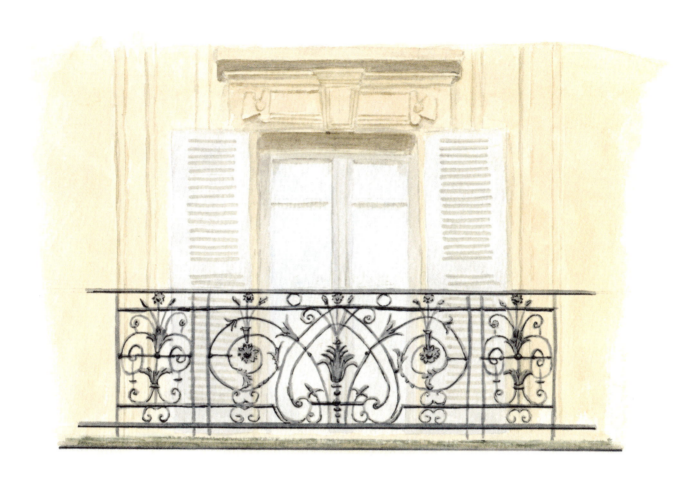

Rue de Vaugirard

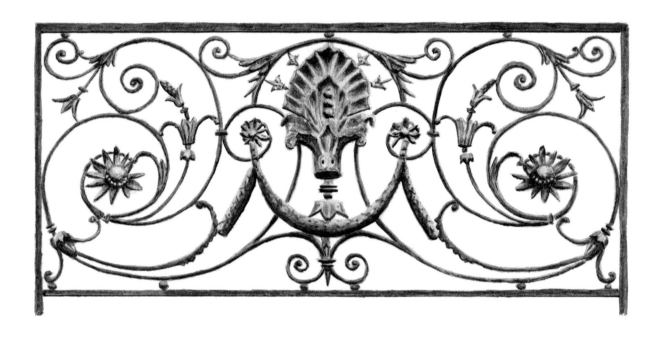

Rue d'Arcole

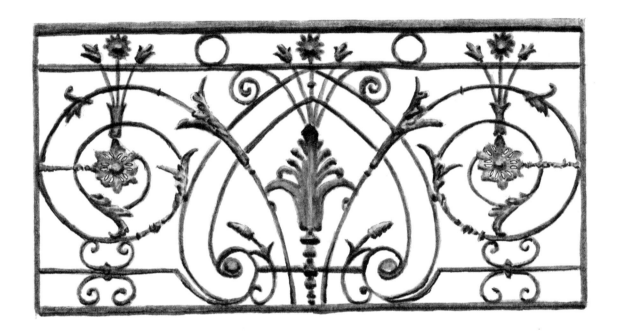

Rue de Vaugirard

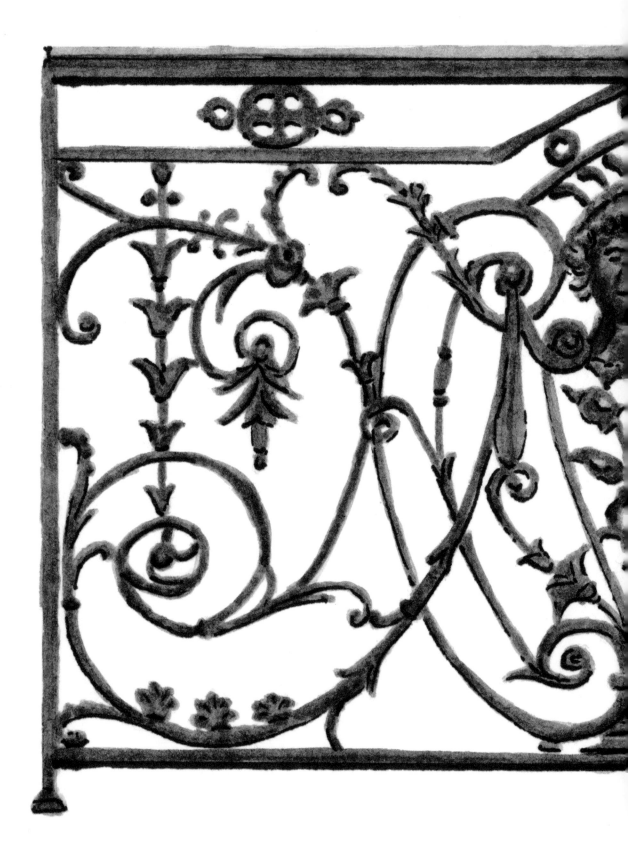

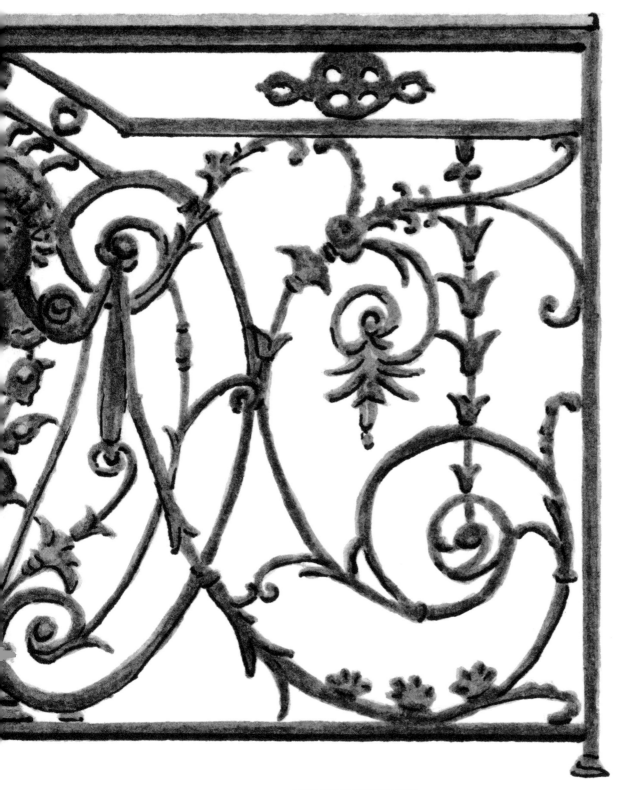

ABOVE AND FOLLOWING PAGES
Place de la République

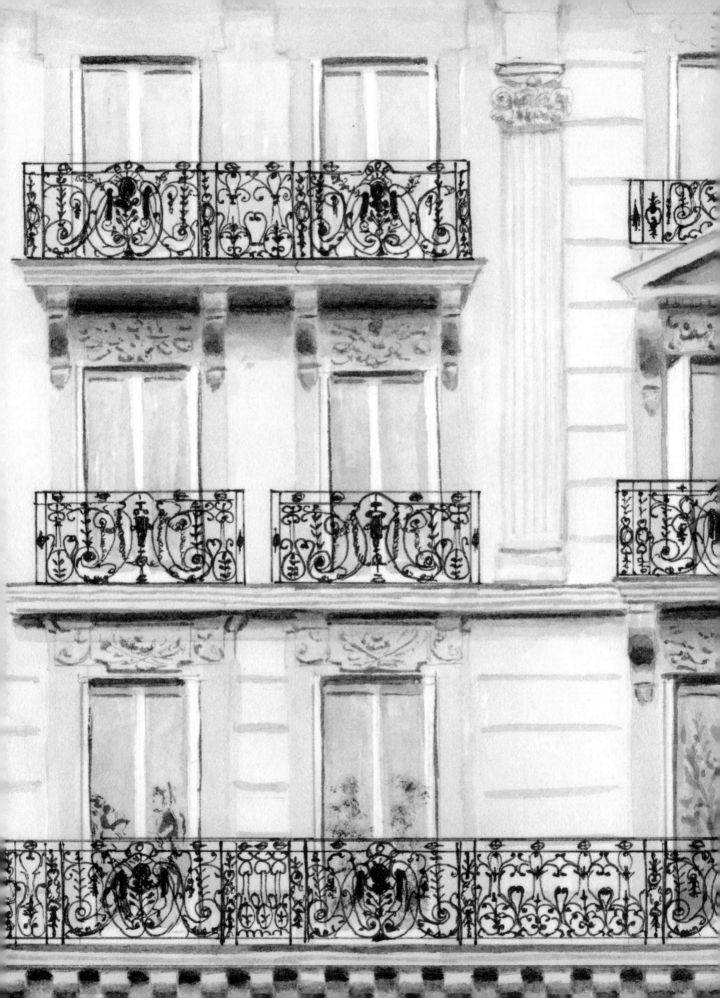

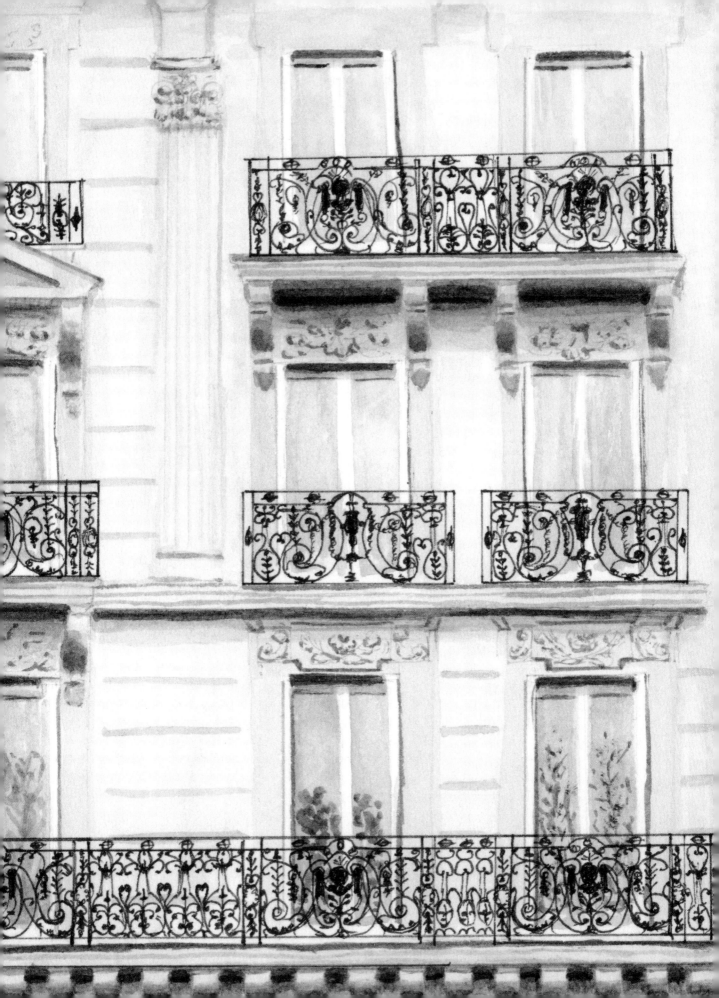

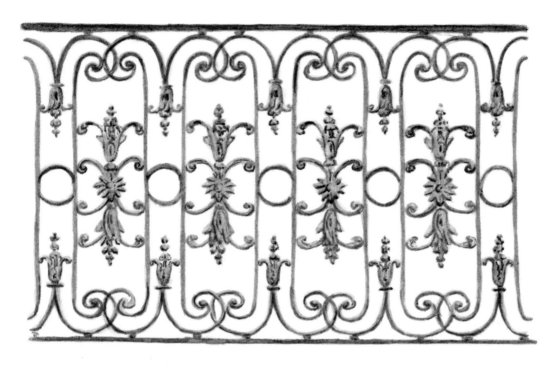

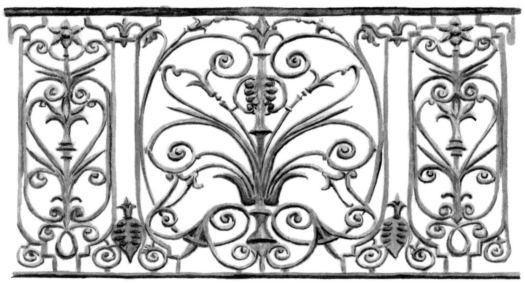

TOP AND OPPOSITE
Place de l'Hôtel-de-Ville

BOTTOM AND FOLLOWING PAGES
Rue d'Arcole

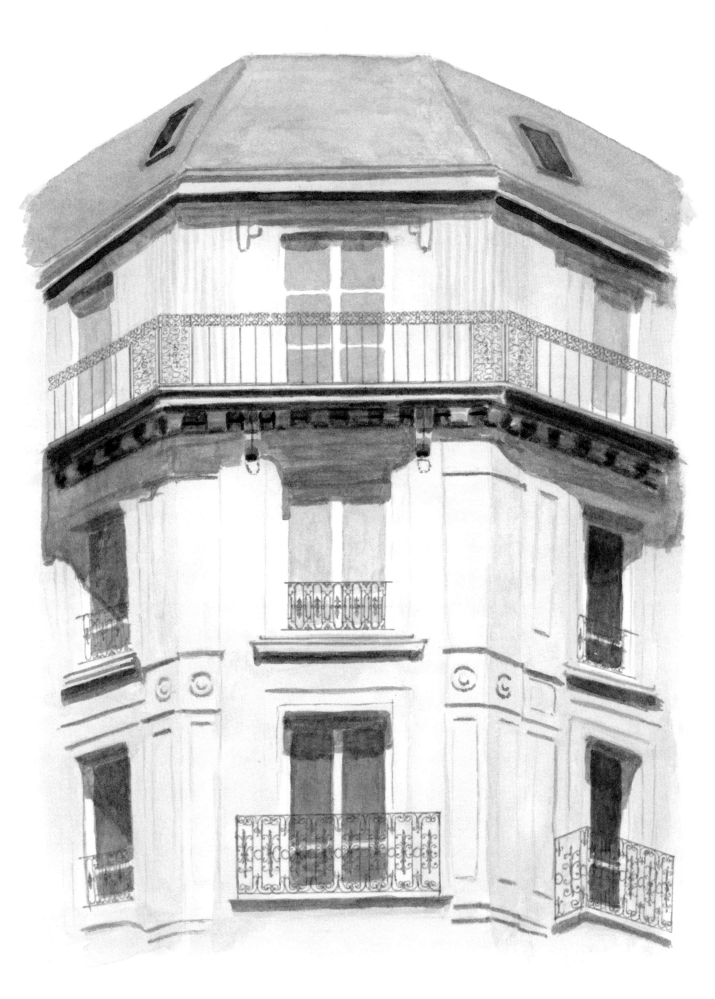

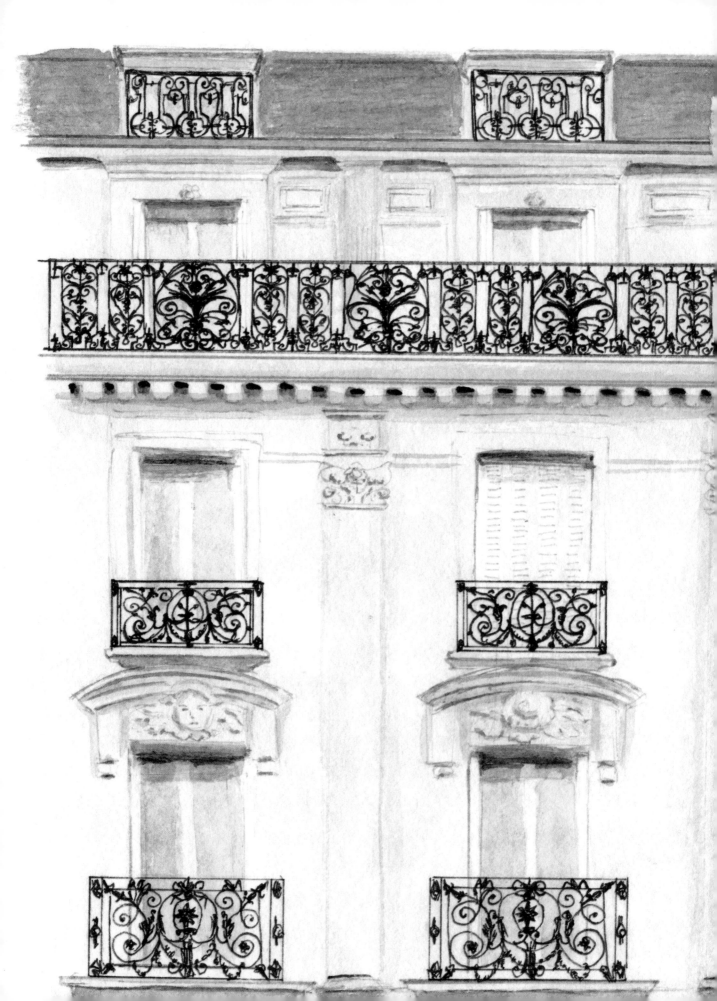

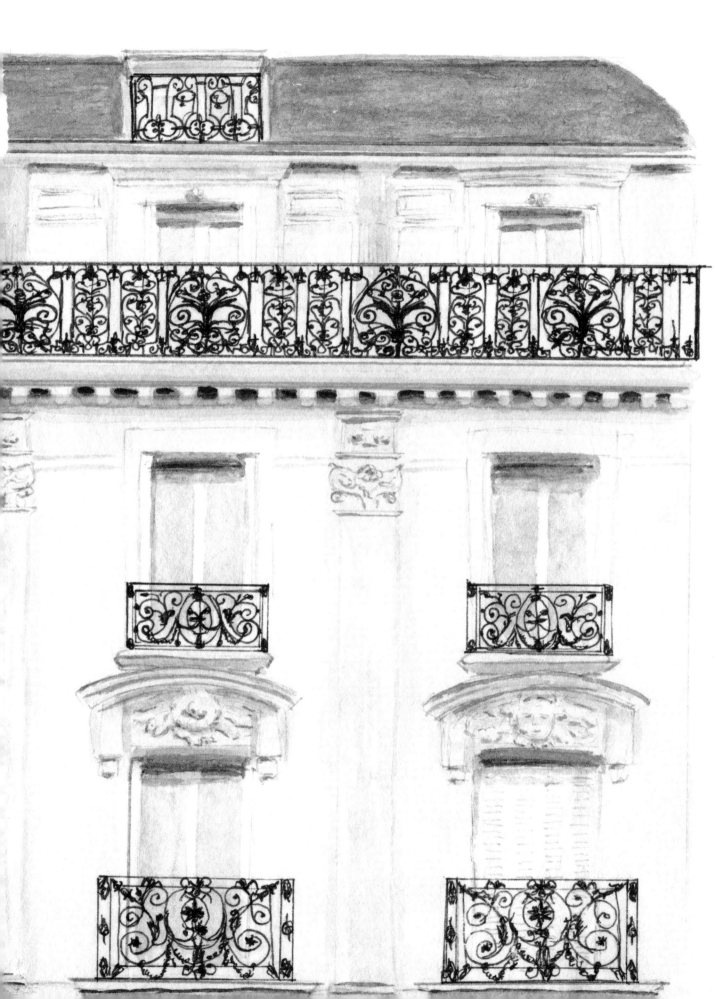

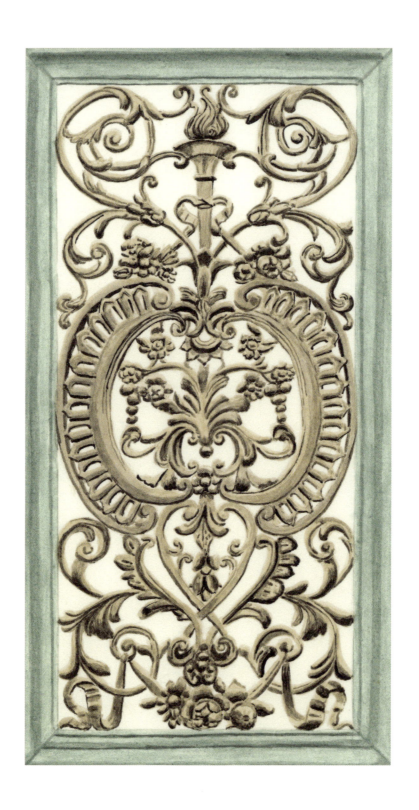

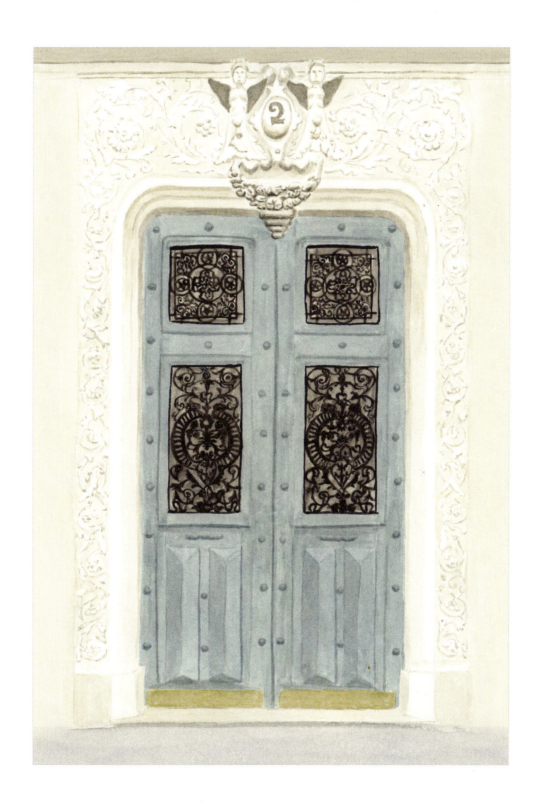

Boulevard des Filles-du-Calvaire

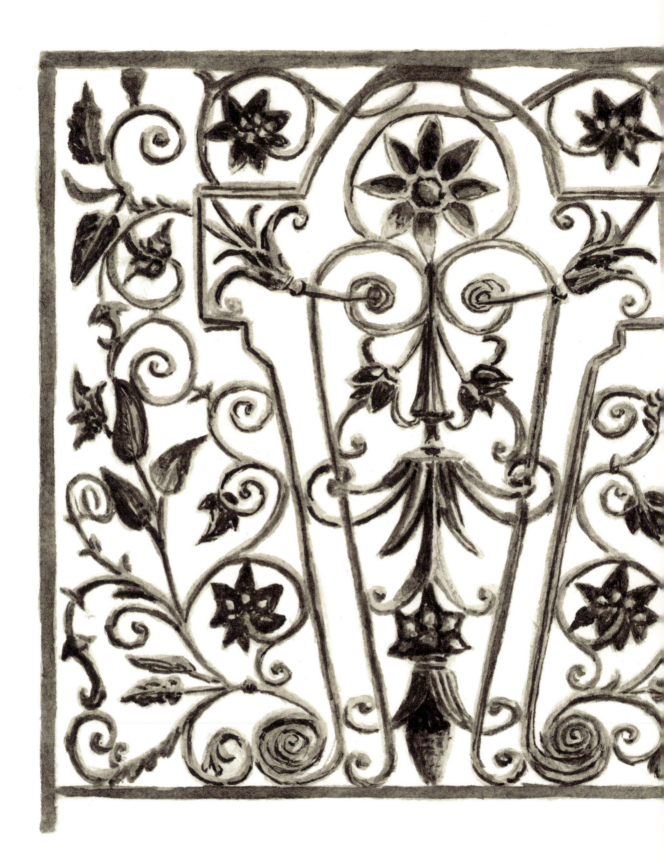

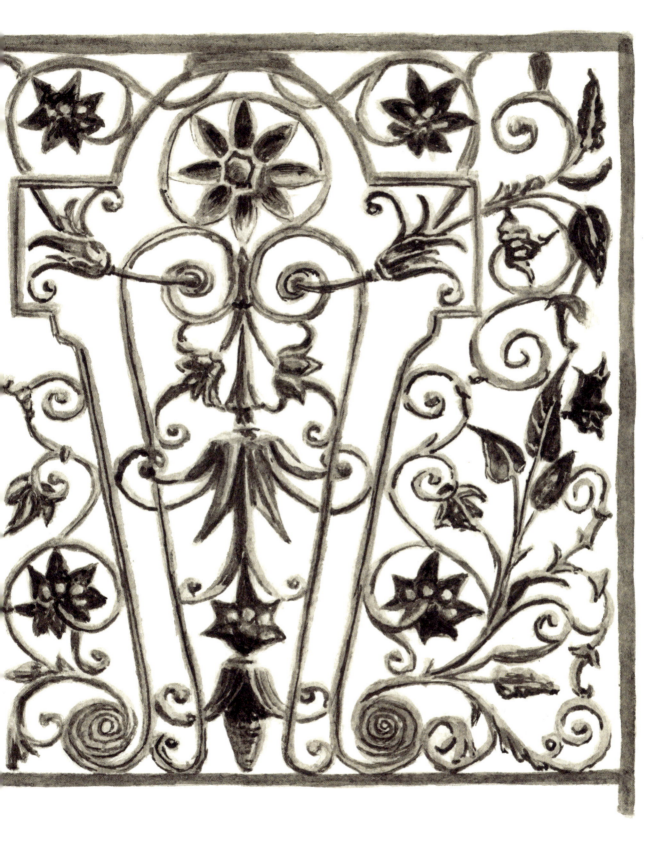

ABOVE AND FOLLOWING PAGES
BOULEVARD DE SÉBASTOPOL

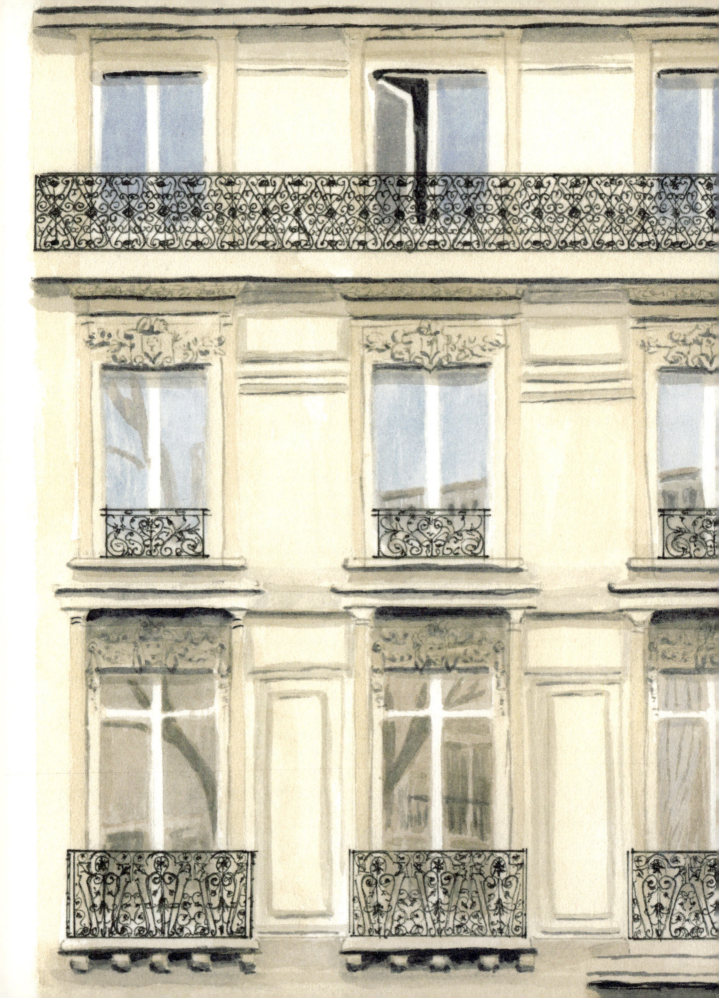

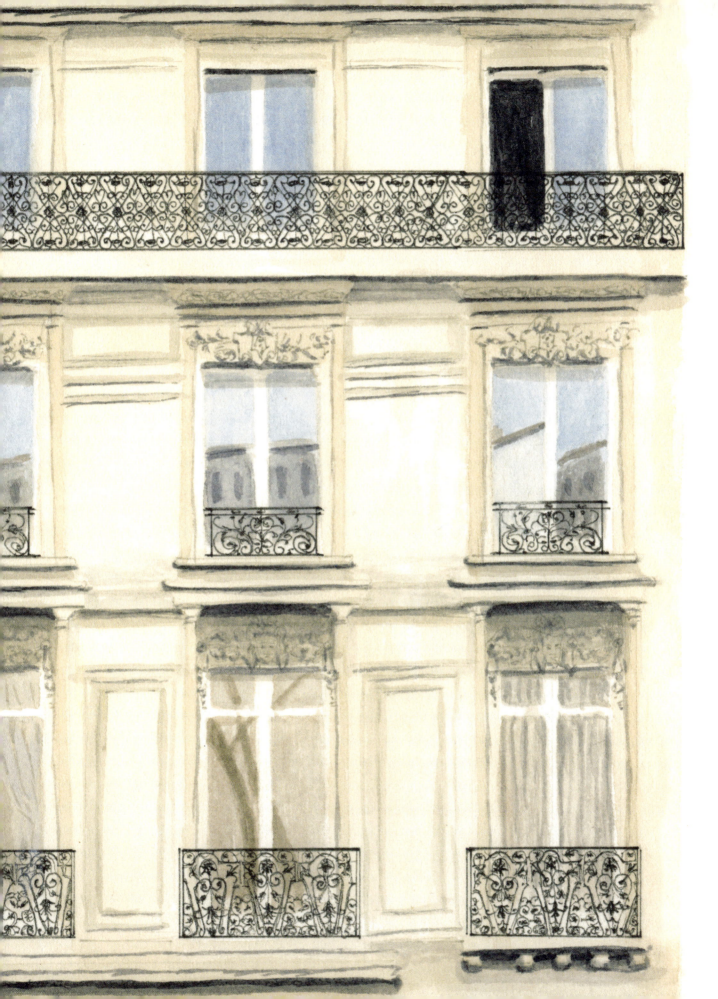

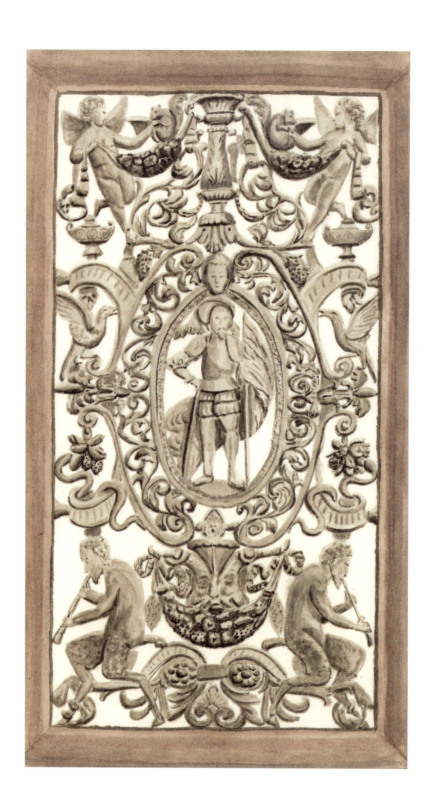

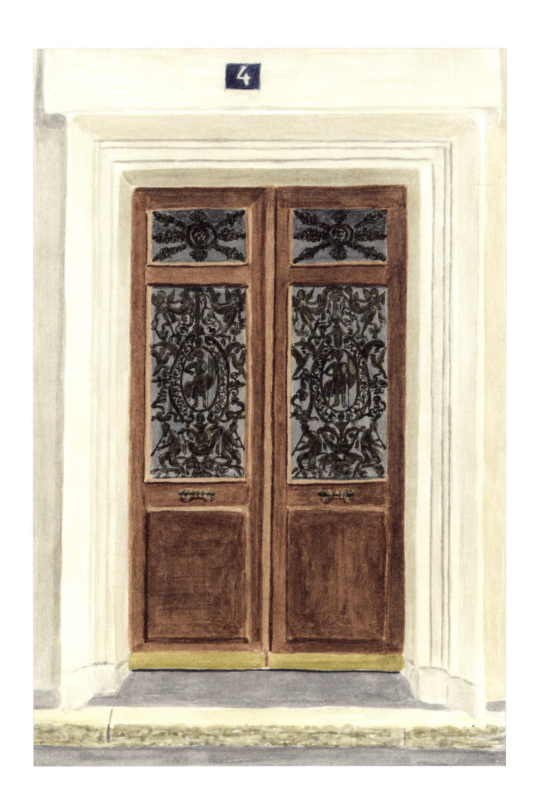

Rue du Pont-Louis-Philippe

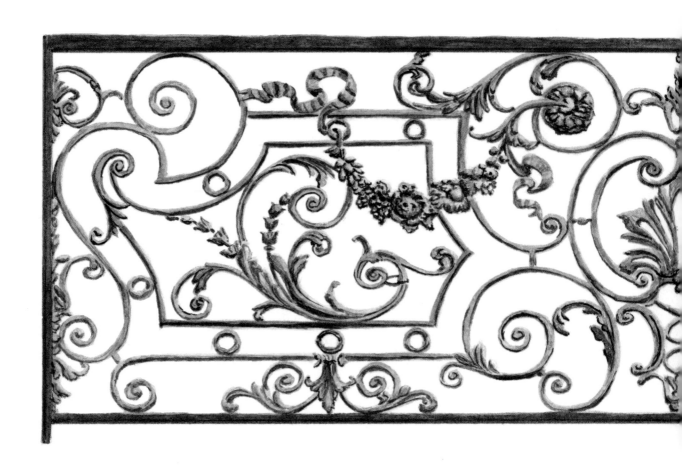

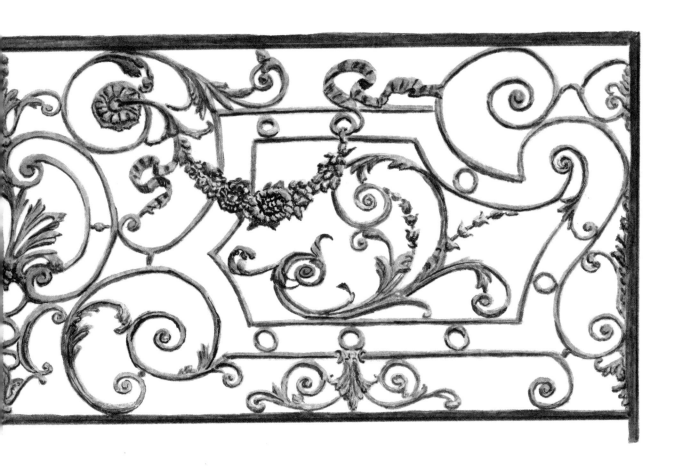

Corner of Rue Malher
and Rue de Rivoli

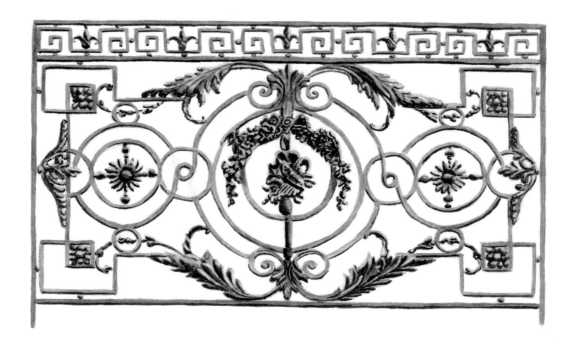

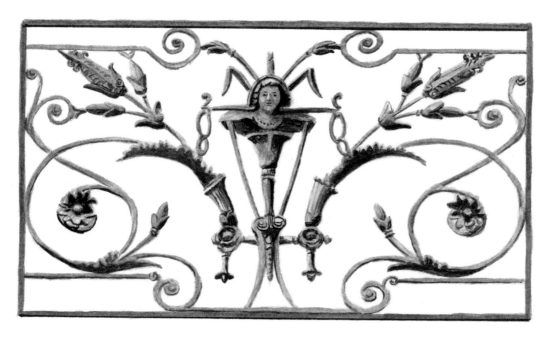

TOP AND OPPOSITE
RUE D'ASSAS

BOTTOM AND FOLLOWING PAGES
PLACE DE LA RÉPUBLIQUE

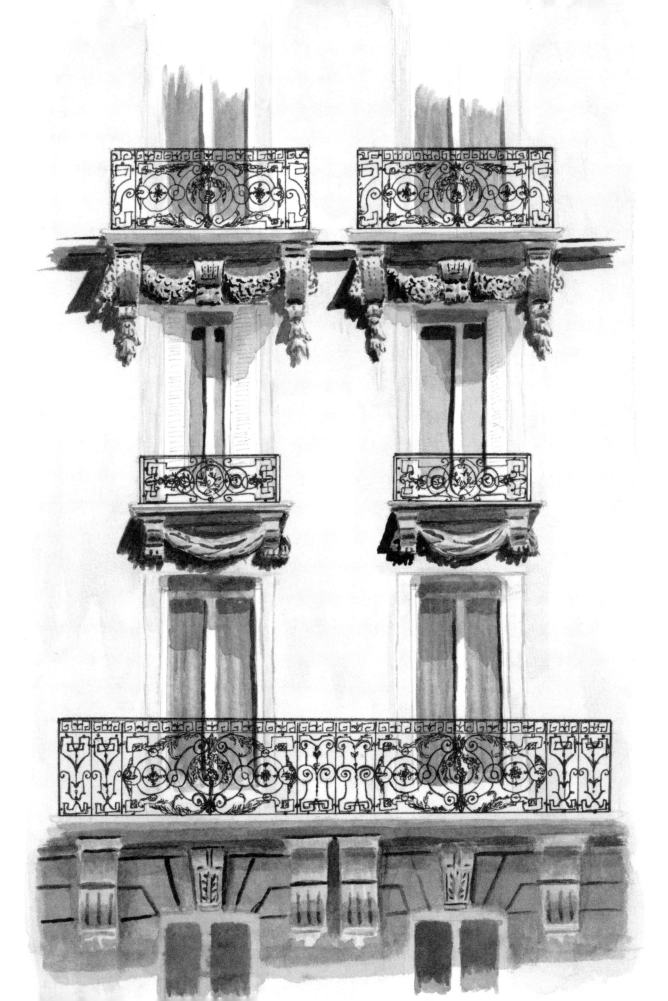

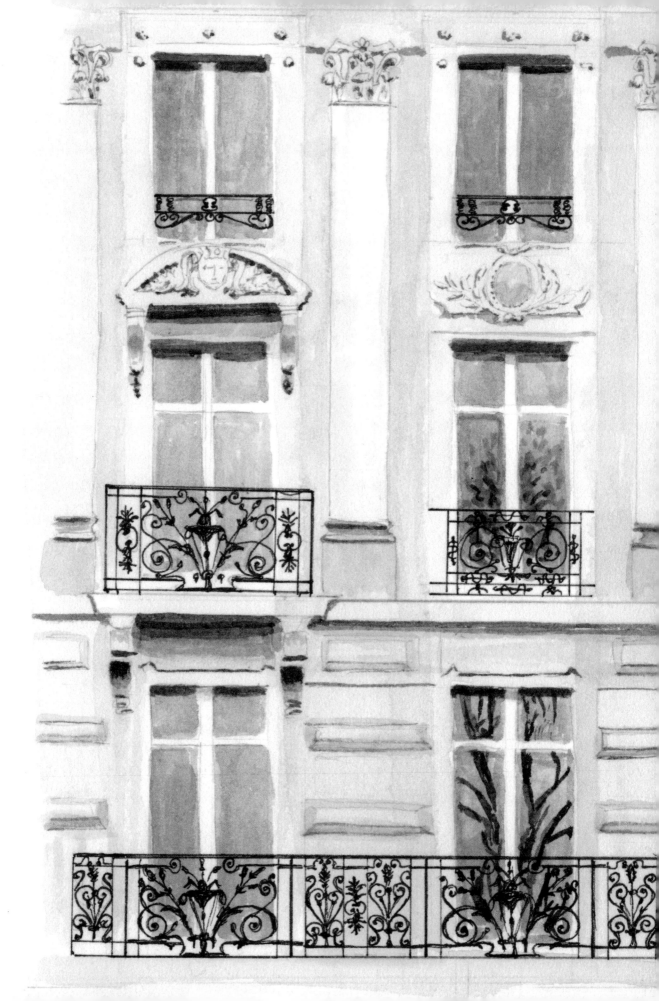

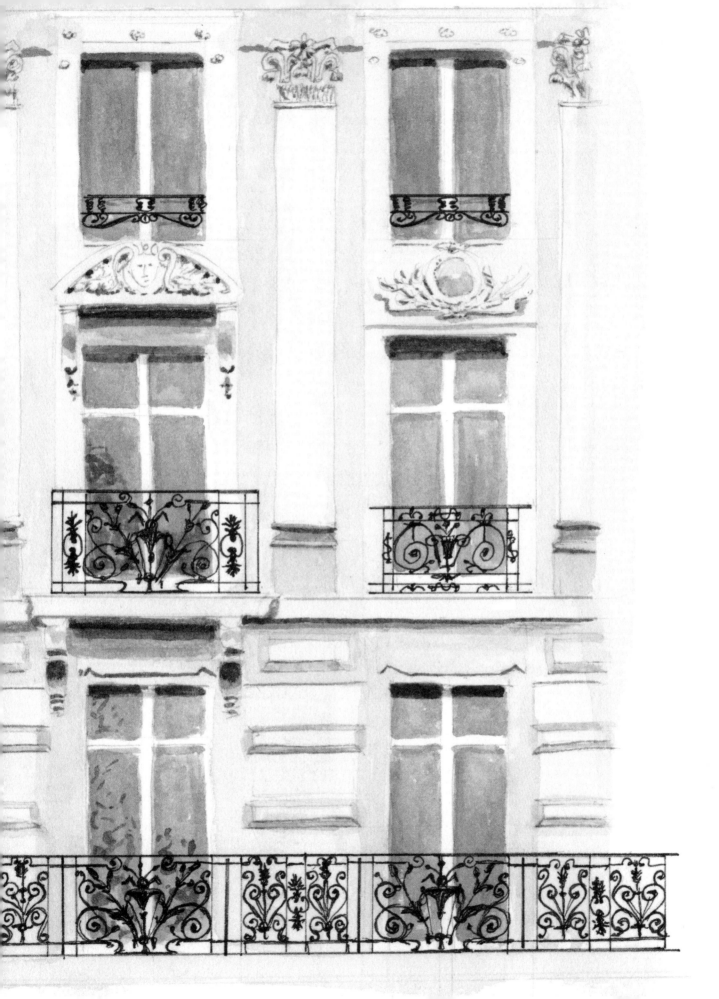

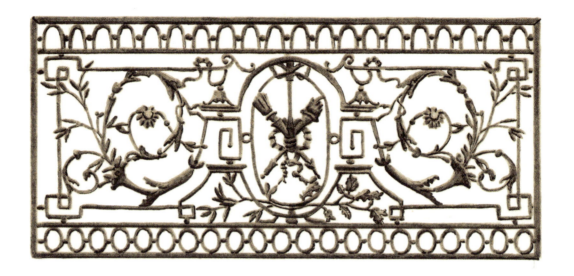

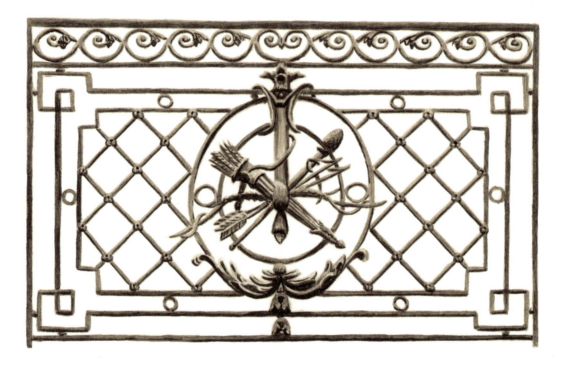

TOP
BOULEVARD SAINT-GERMAIN

BOTTOM
RUE DE TOLBIAC

OPPOSITE
BOULEVARD DU MONTPARNASSE

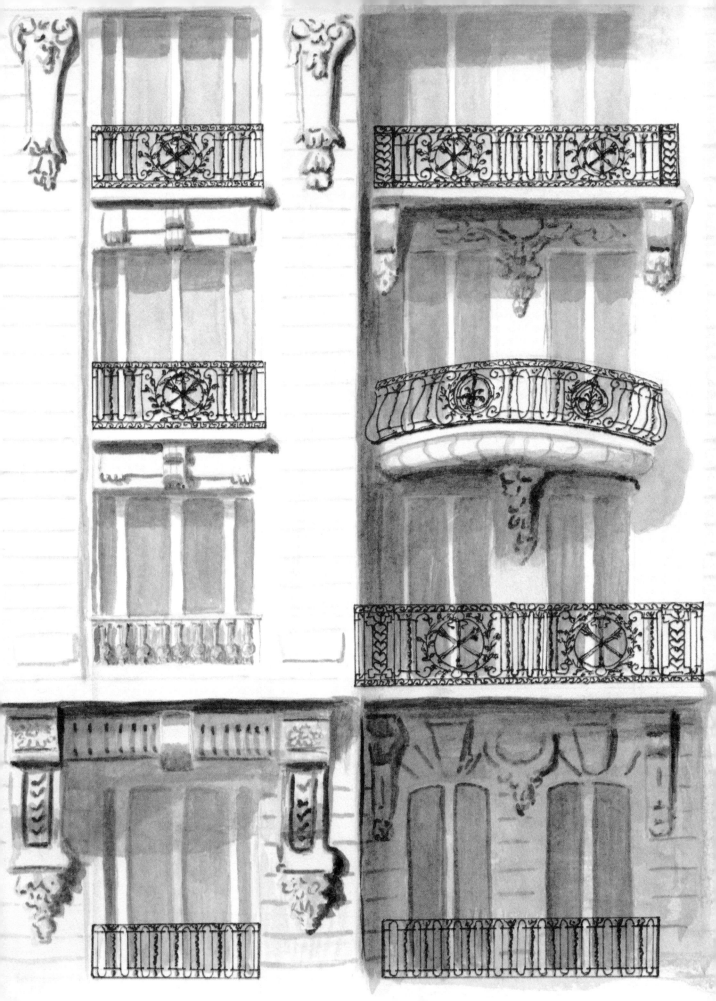

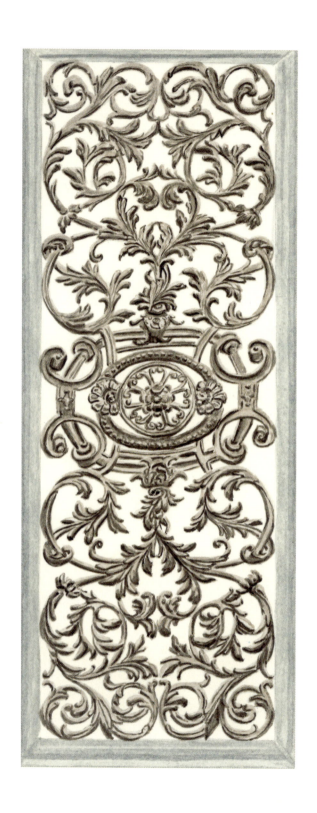

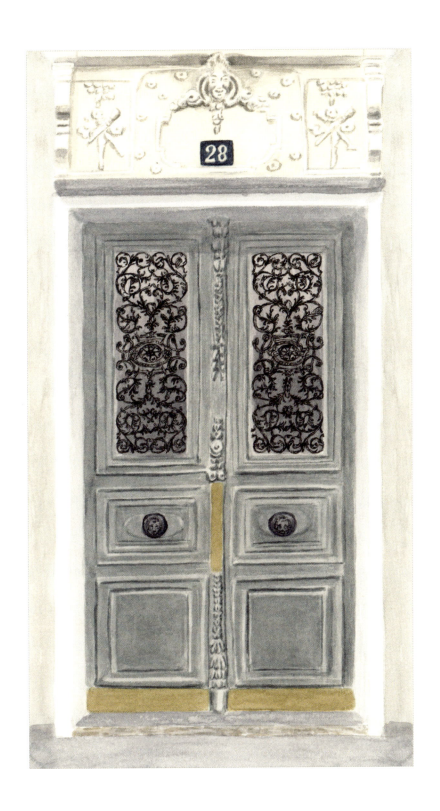

Rue Biscornet

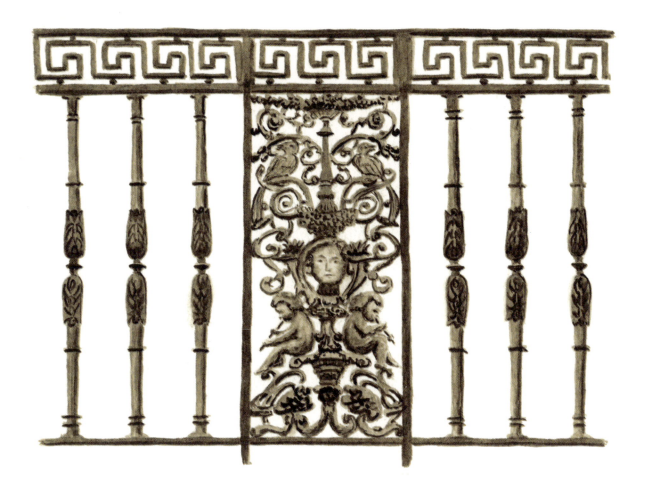

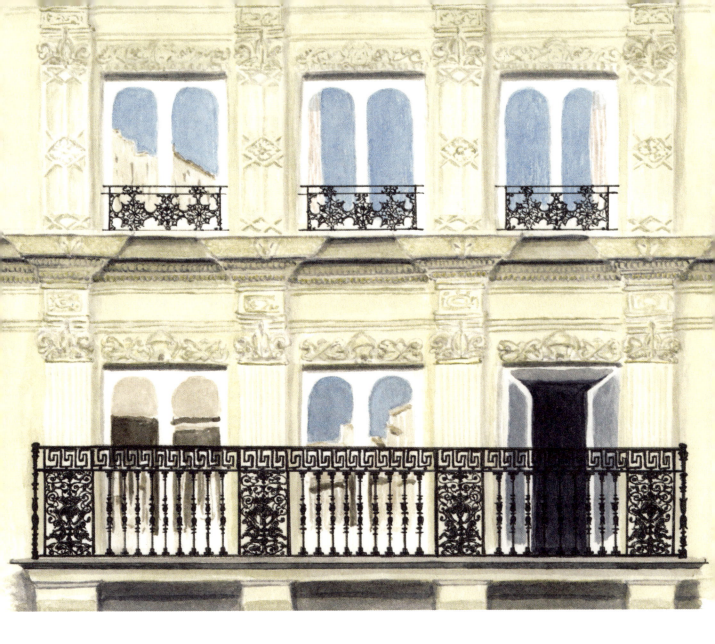

Rue de Fleurus

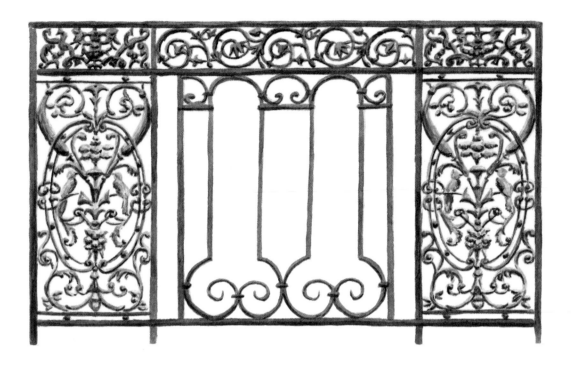

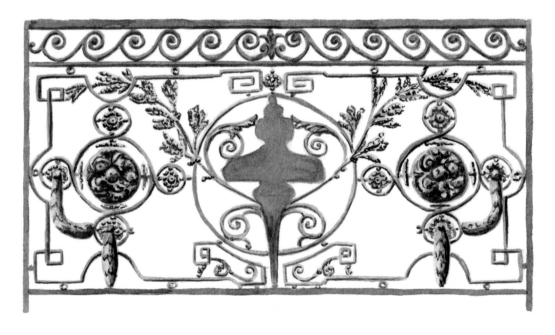

TOP AND OPPOSITE
BOULEVARD SAINT-MICHEL

BOTTOM AND FOLLOWING PAGES
RUE DE RENNES

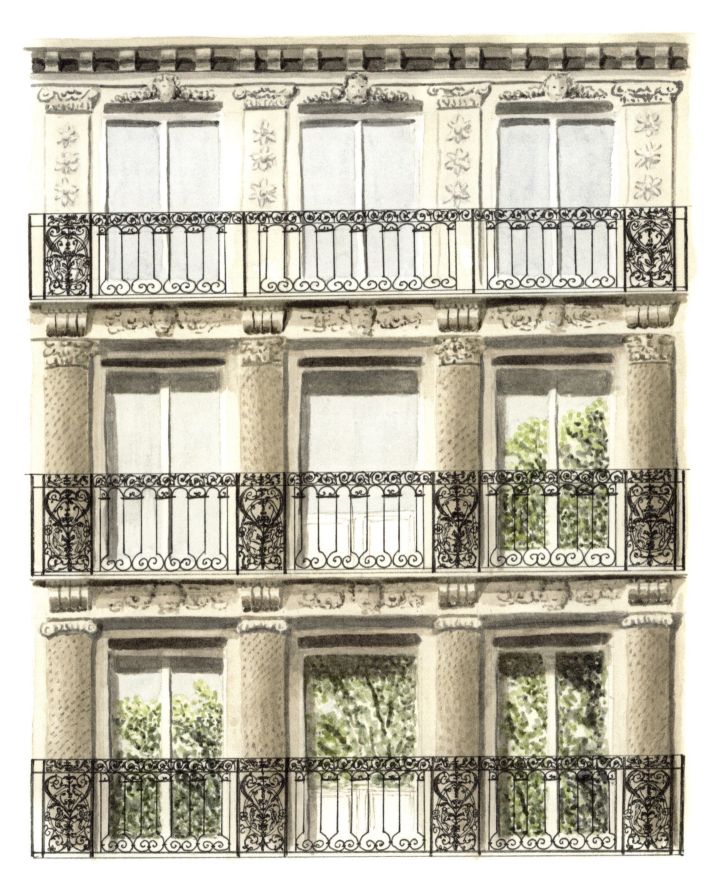

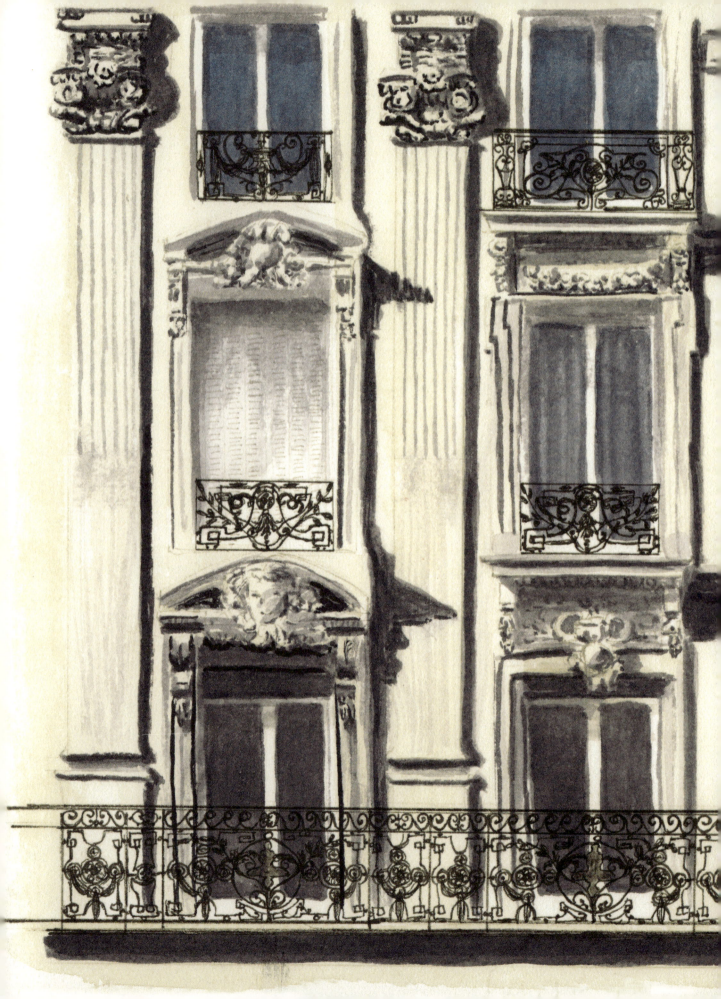

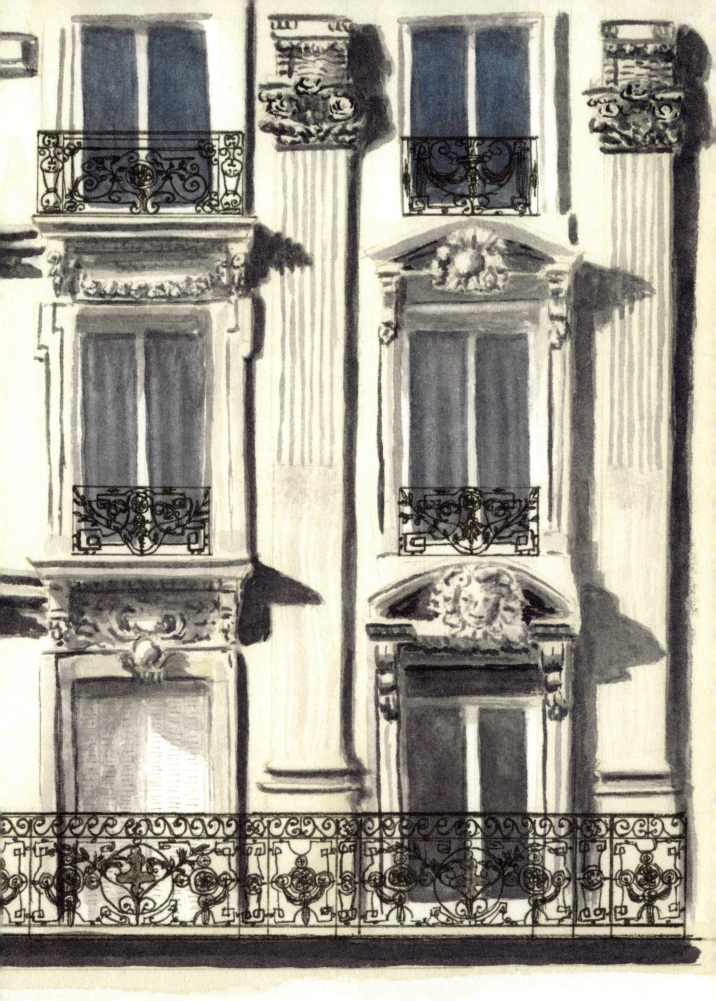

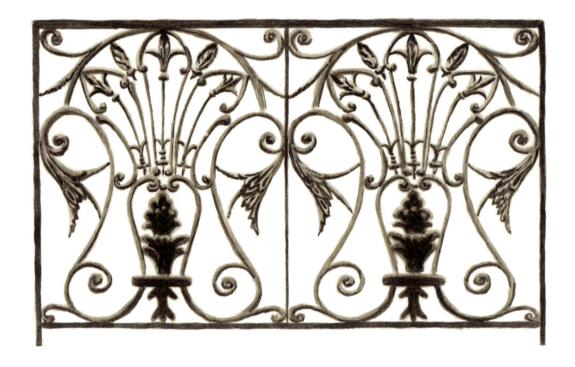

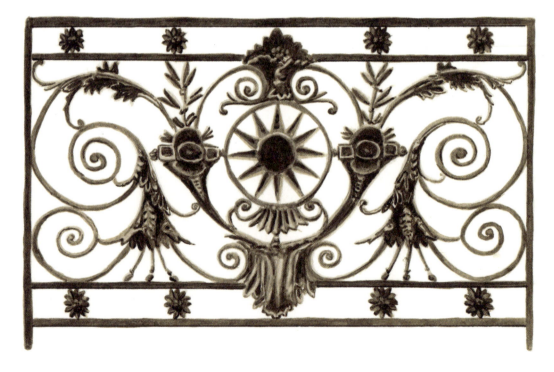

ABOVE AND OPPOSITE
RUE DE L'ÉCHELLE

FOLLOWING PAGES
RUE DE RENNES

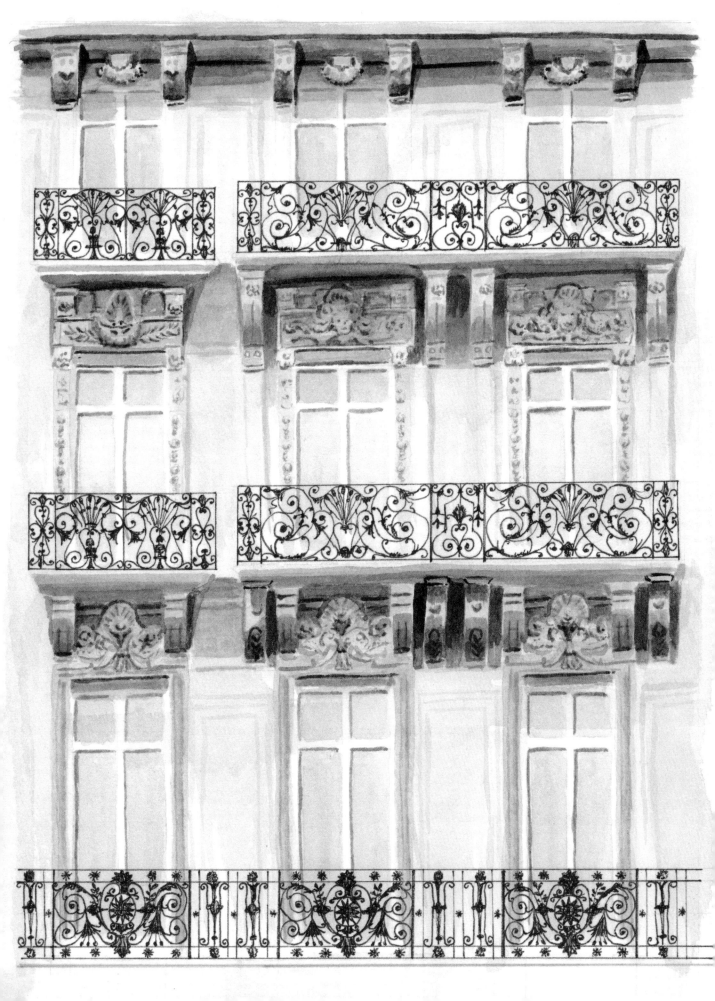

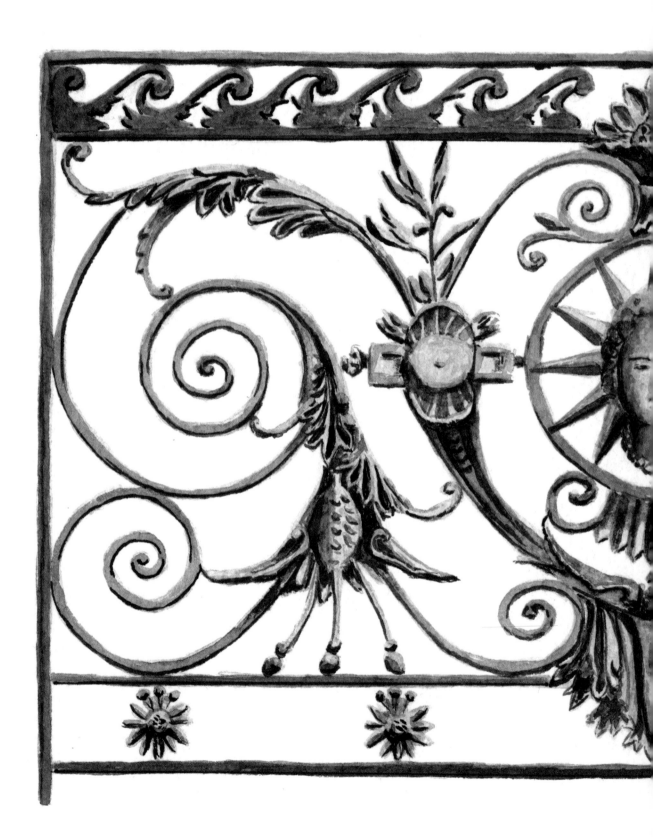

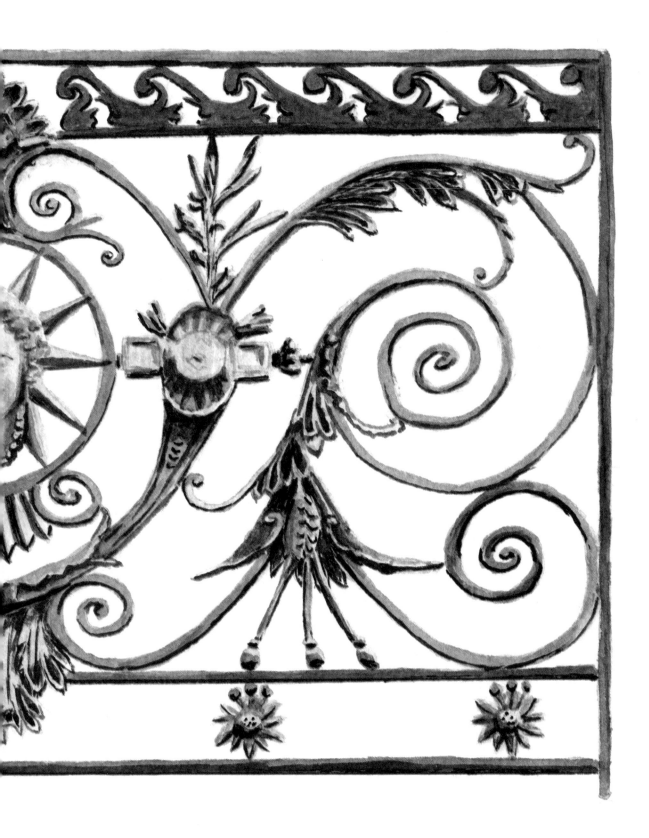

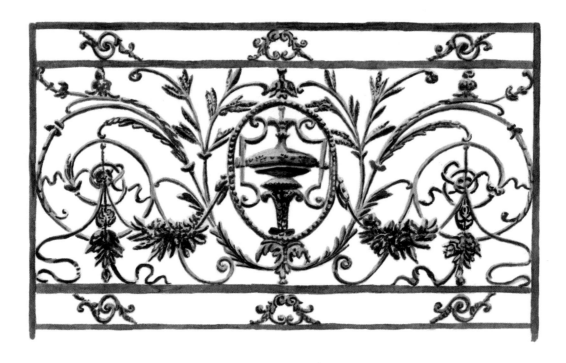

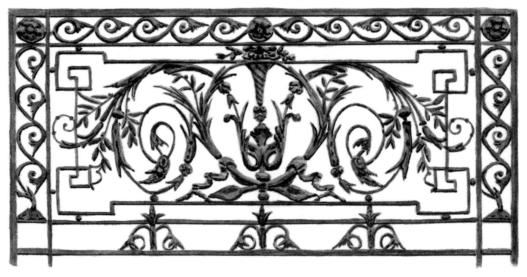

TOP AND OPPOSITE
BOULEVARD SAINT-GERMAIN

BOTTOM AND FOLLOWING PAGES
RUE DE RENNES

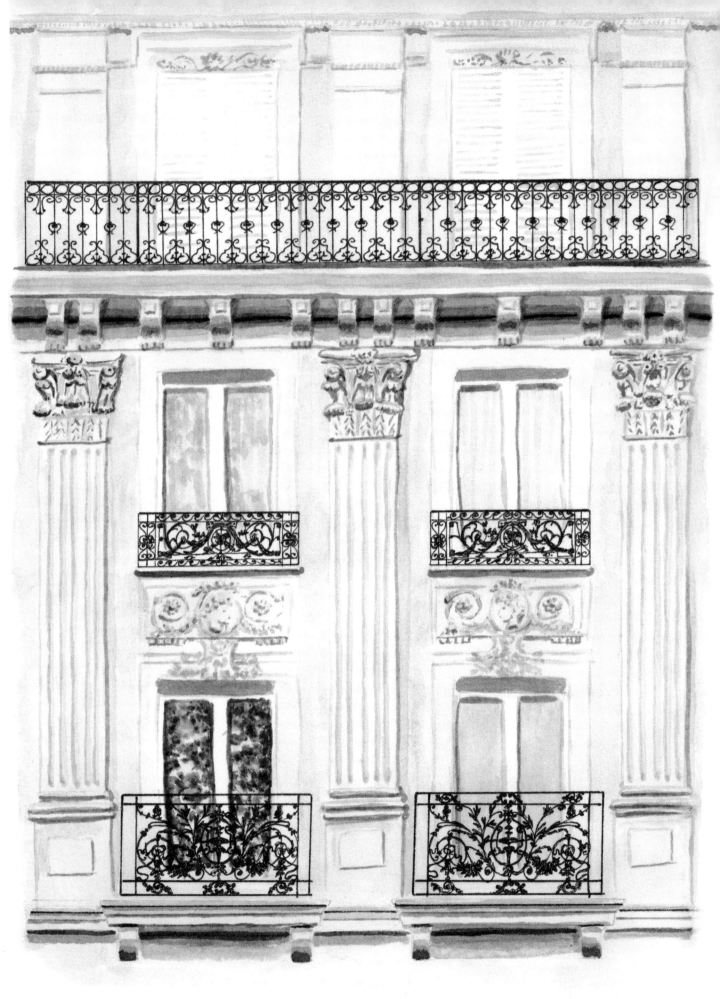

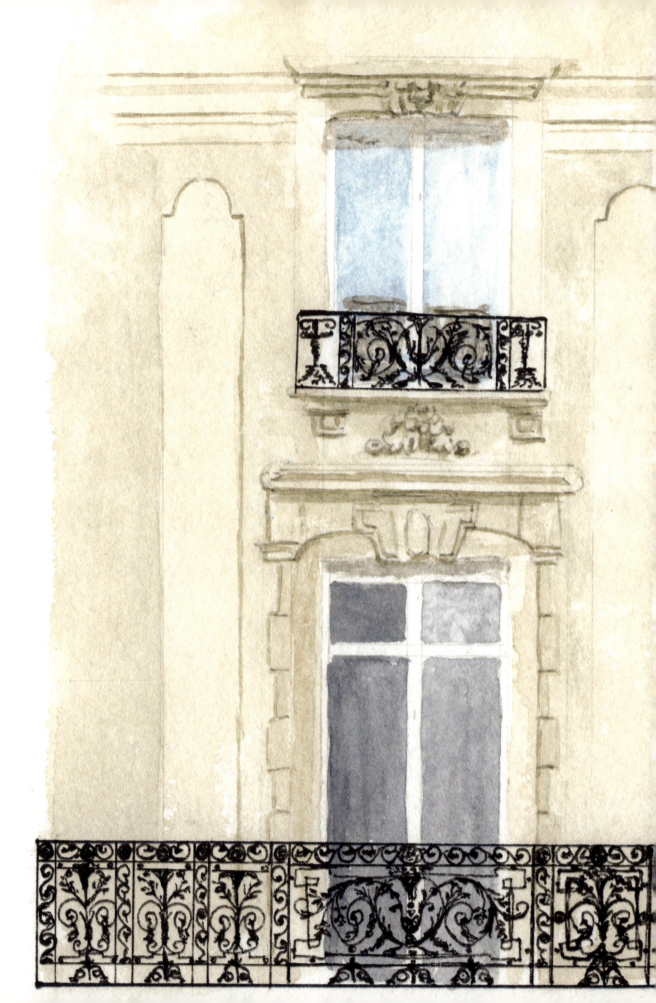

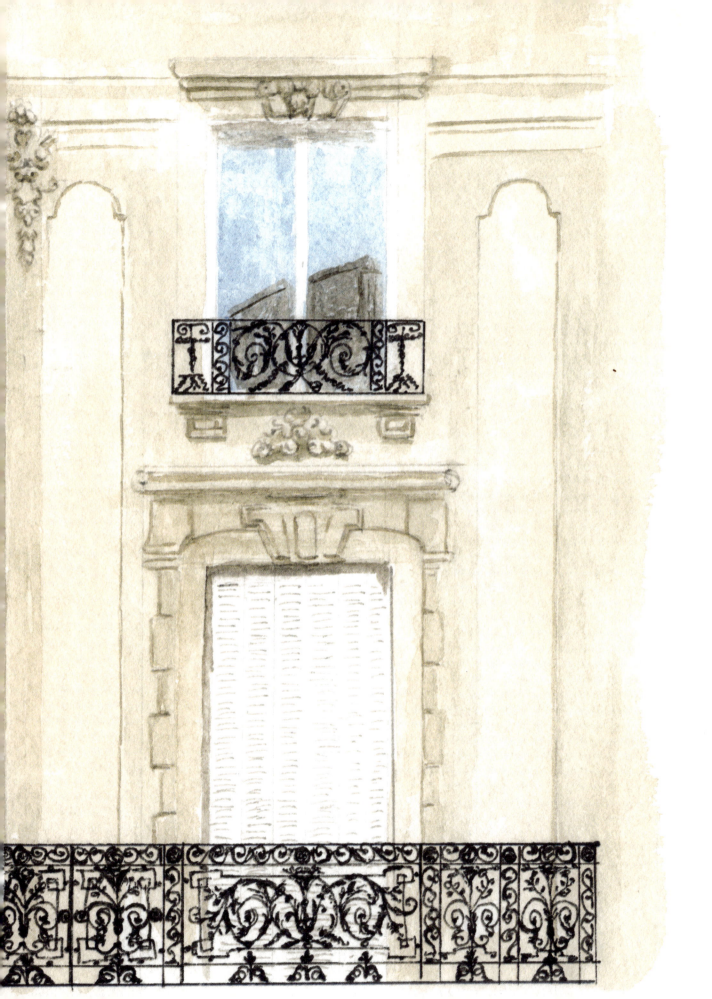

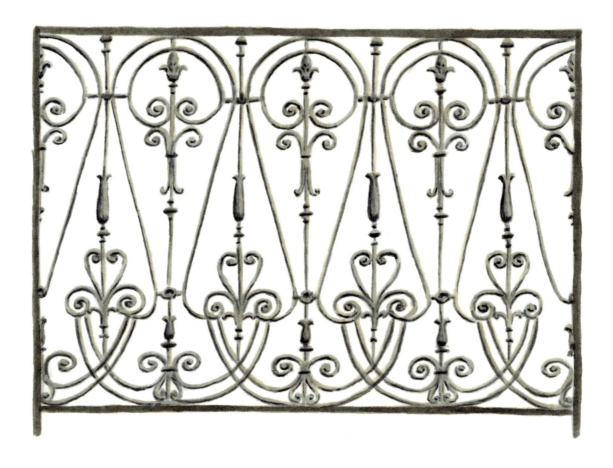

Boulevard Saint-Michel

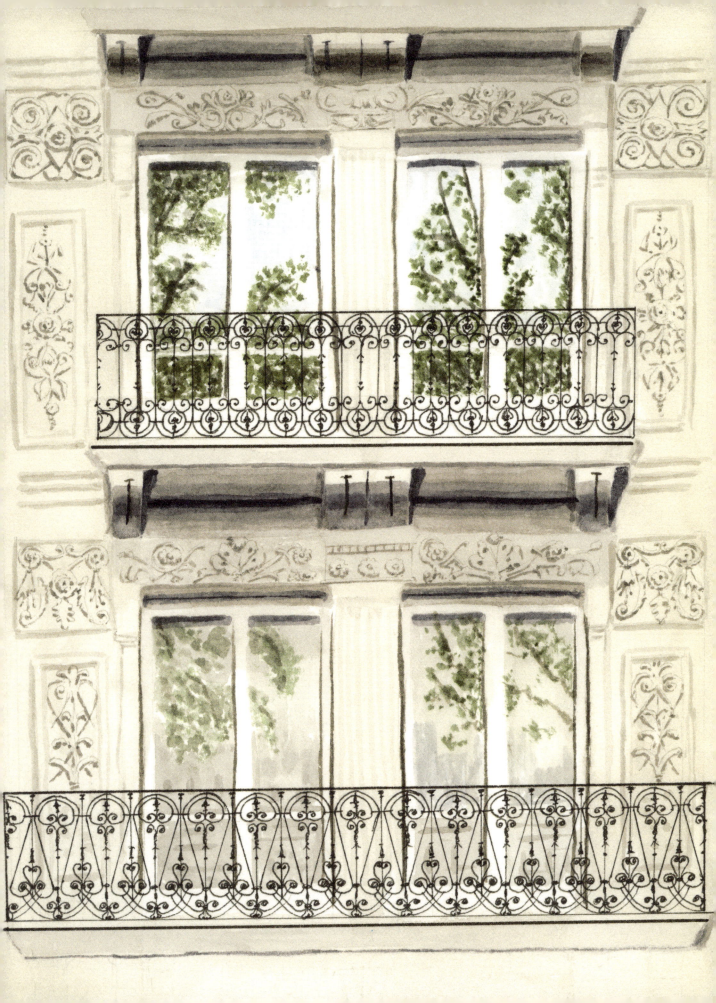

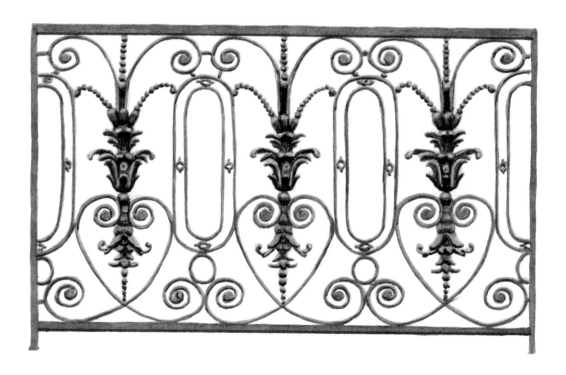

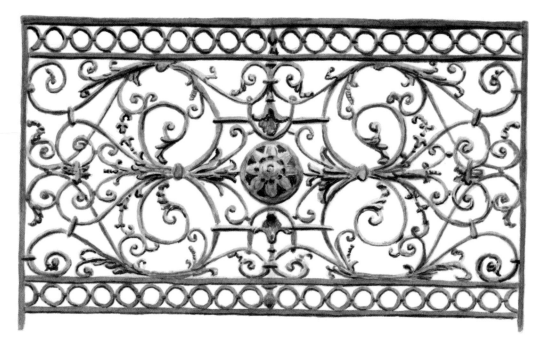

TOP AND OPPOSITE
AVENUE MARCEAU

BOTTOM AND FOLLOWING PAGES
AVENUE DE L'OPÉRA

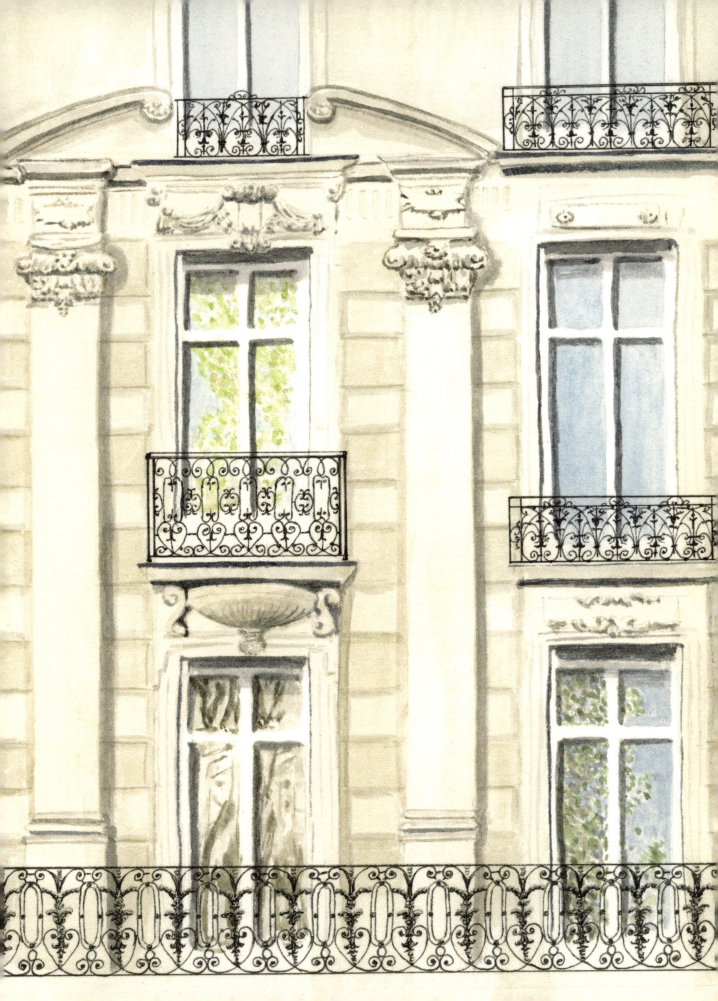

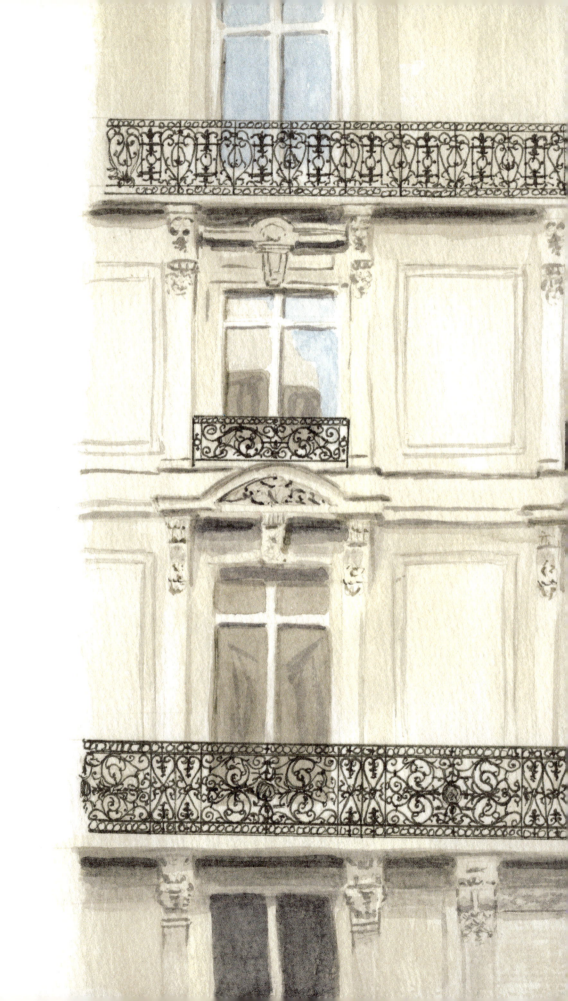

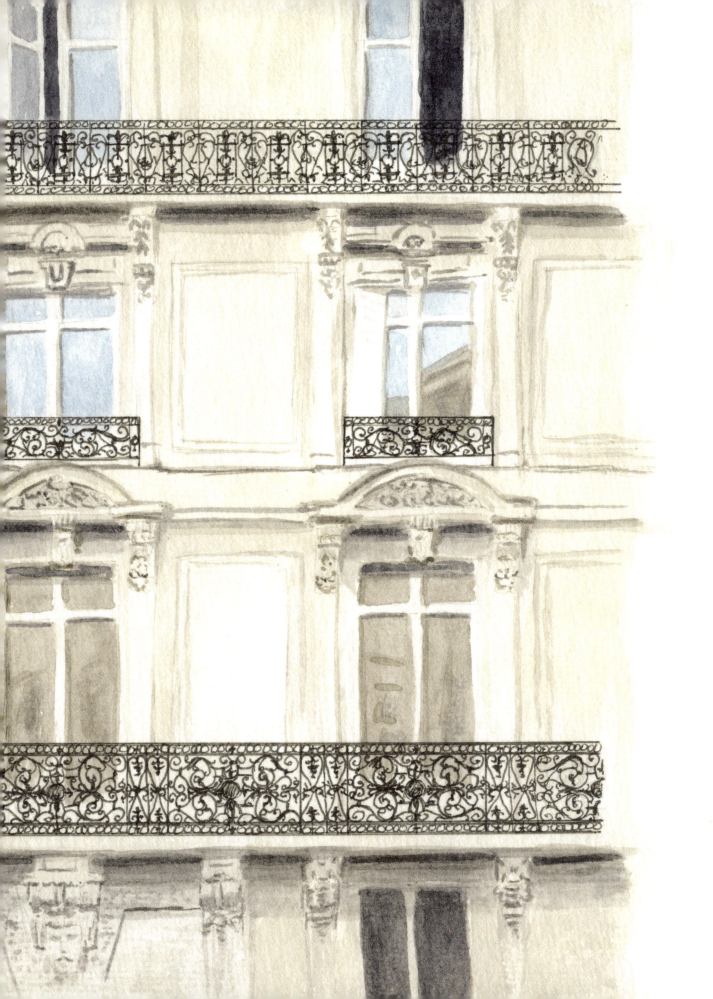

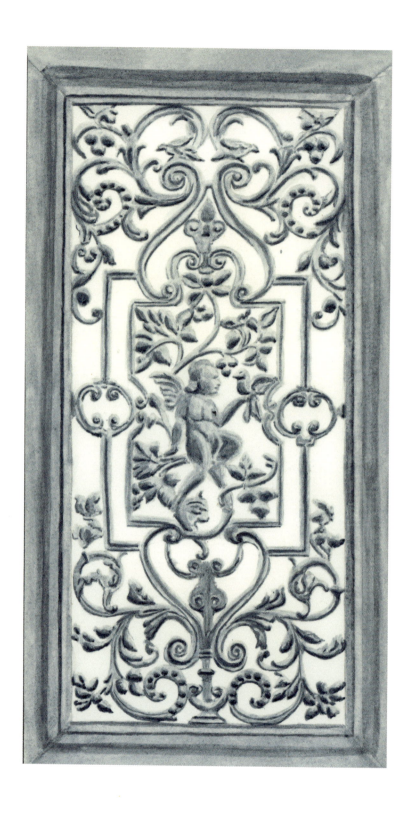

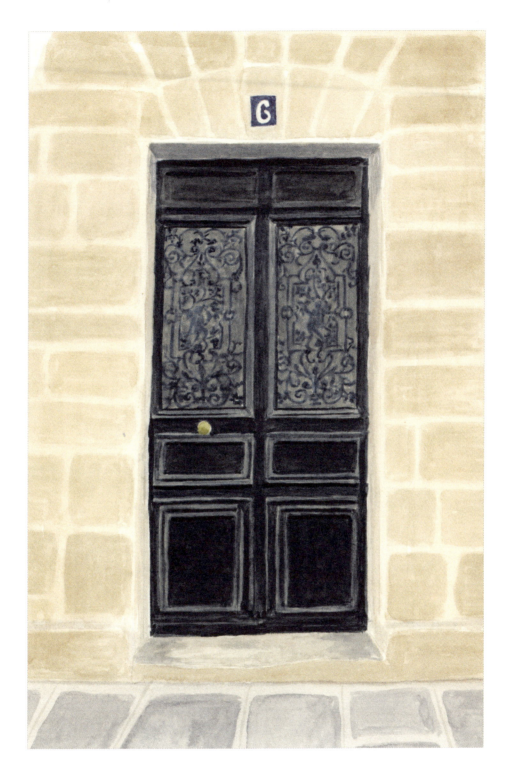

OPPOSITE AND ABOVE
RUE LE REGRATTIER

FOLLOWING PAGES
BOULEVARD SAINT-GERMAIN

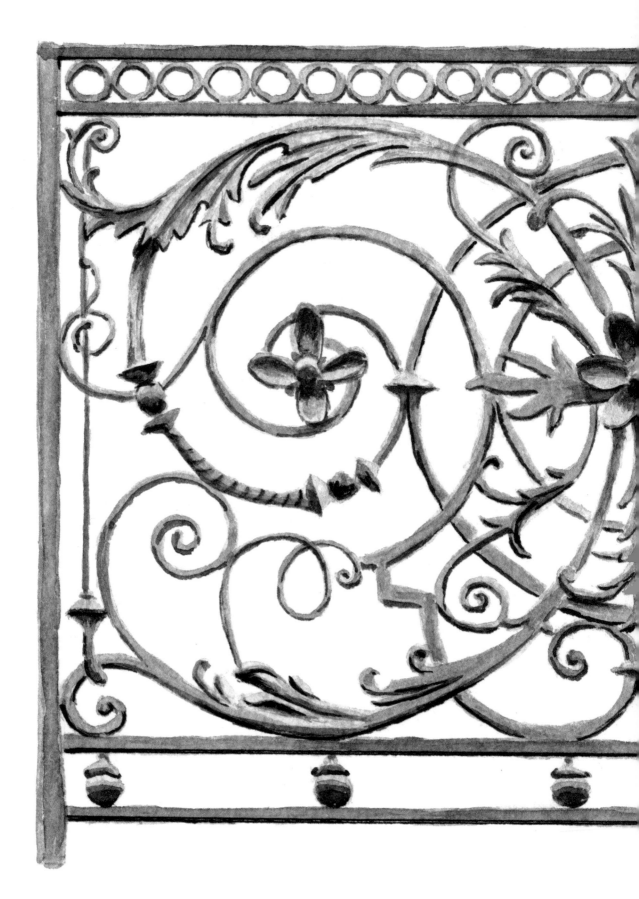

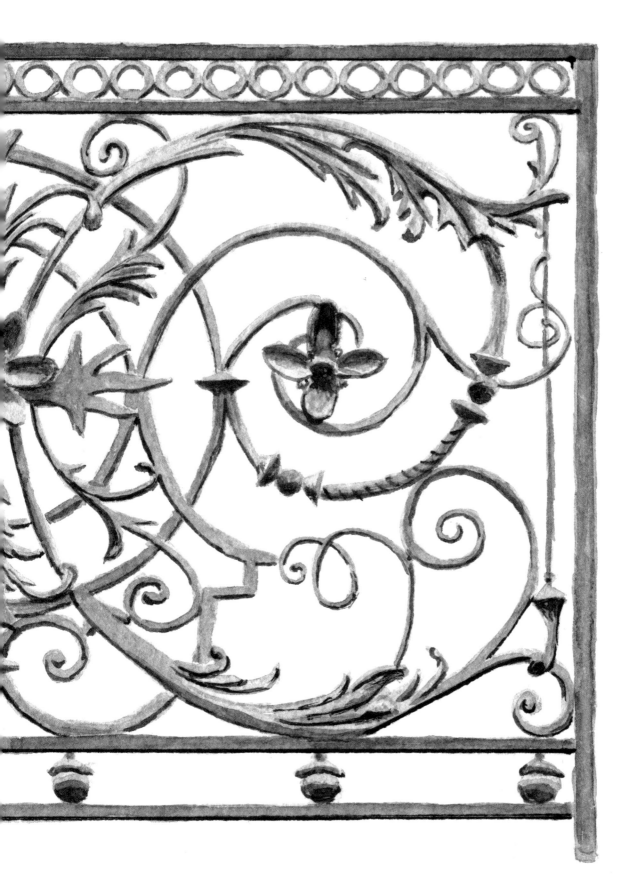

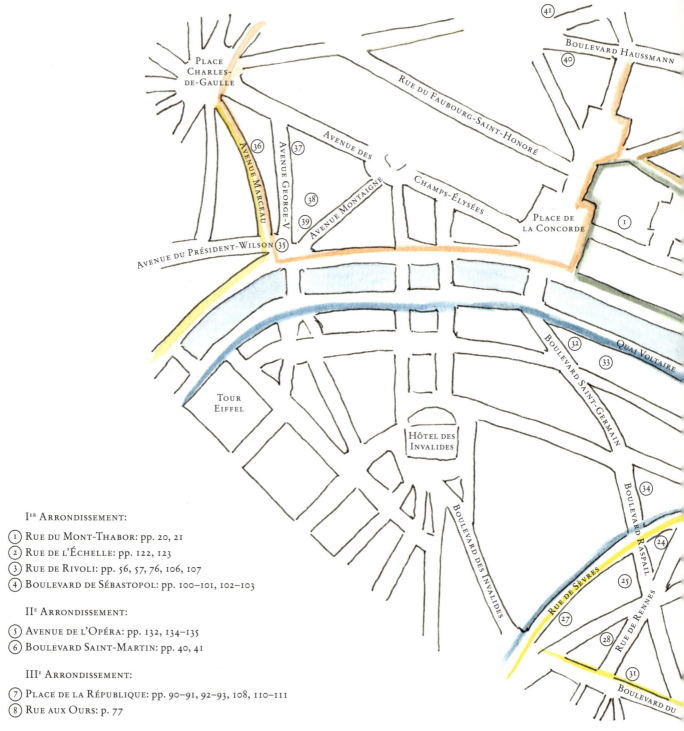

Iᴇʀ Arrondissement:

① Rue du Mont-Thabor: pp. 20, 21
② Rue de l'Échelle: pp. 122, 123
③ Rue de Rivoli: pp. 56, 57, 76, 106, 107
④ Boulevard de Sébastopol: pp. 100–101, 102–103

IIᴇ Arrondissement:

⑤ Avenue de l'Opéra: pp. 132, 134–135
⑥ Boulevard Saint-Martin: pp. 40, 41

IIIᴇ Arrondissement:

⑦ Place de la République: pp. 90–91, 92–93, 108, 110–111
⑧ Rue aux Ours: p. 77

IVᴇ Arrondissement:

⑨ Place de l'Hôtel-de-Ville: pp. 94, 95
⑩ Rue des Archives: pp. 74–75
⑪ Rue Malher: pp. 106, 107
⑫ Rue Sévigné: pp. 24–25, 26
⑬ Place Pierre-Kauffmann: pp. 27, 28–29
⑭ Rue du Pont-Louis-Philippe: pp. 46, 47, 104, 105
⑮ Rue de Lutèce: pp. 20, 22–23
⑯ Rue d'Arcole: pp. 86, 88, 94, 96–97
⑰ Quai aux Fleurs: pp. 11, 12, 13, 68, 70–71
⑱ Rue Le Regrattier: pp. 136, 137
⑲ Rue Saint-Louis-en-l'Île: pp. 30, 31

Vᴇ Arrondissement:

⑳ Quai Saint-Michel: p. 76
㉑ Boulevard Saint-Michel: pp. 36, 38–39, 50–51, 118, 119, 130, 131

VIᴇ Arrondissement:

㉒ Rue des Grands-Augustins: pp. 14, 15
㉓ Rue Danton: pp. 64, 65, 66–67
㉔ Place Michel-Debré: pp. 48, 49
㉕ Rue du Regard: pp. 78, 79
㉖ Rue de Vaugirard: pp. 87, 89
㉗ Rue de Sèvres: pp. 18, 19, 58

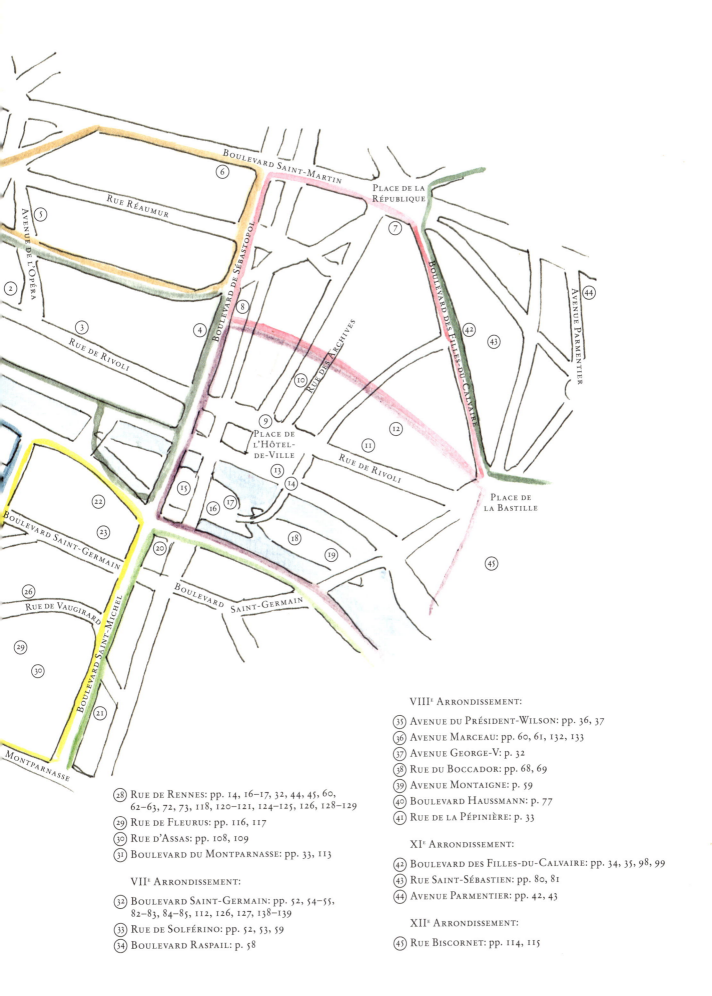

VIII^e Arrondissement:

㉟ Avenue du Président-Wilson: pp. 36, 37
㊱ Avenue Marceau: pp. 60, 61, 132, 133
㊲ Avenue George-V: p. 32
㊳ Rue du Boccador: pp. 68, 69
㊴ Avenue Montaigne: p. 59
㊵ Boulevard Haussmann: p. 77
㊶ Rue de la Pépinière: p. 33

XI^e Arrondissement:

㊷ Boulevard des Filles-du-Calvaire: pp. 34, 35, 98, 99
㊸ Rue Saint-Sébastien: pp. 80, 81
㊹ Avenue Parmentier: pp. 42, 43

XII^e Arrondissement:

㊺ Rue Biscornet: pp. 114, 115

㉘ Rue de Rennes: pp. 14, 16–17, 32, 44, 45, 60, 62–63, 72, 73, 118, 120–121, 124–125, 126, 128–129
㉙ Rue de Fleurus: pp. 116, 117
㉚ Rue d'Assas: pp. 108, 109
㉛ Boulevard du Montparnasse: pp. 33, 113

VII^e Arrondissement:

㉜ Boulevard Saint-Germain: pp. 52, 54–55, 82–83, 84–85, 112, 126, 127, 138–139
㉝ Rue de Solférino: pp. 52, 53, 59
㉞ Boulevard Raspail: p. 58

Acknowledgments

I would sincerely like to thank Jacques Leibowitch, without whom this book may not have been possible, as he is the person who introduced me to Catherine Bonifassi. He encouraged the development of this project and supported me, as always. However, he will not be able to discover the final result. It is my deep regret.

I would also like to thank Sylvie Villeminot, who readily sent me a few photos captured near her home during lockdown. In addition to offering beautiful discoveries, they allowed me to continue to draw and paint.

Thank you to Rizzoli Publications and the team at Cassi Edition for their work and support.

—Dominique Mathez

Rizzoli Publications would like to thank Dominique Mathez.

Thanks as well to Christophe Averty and Joël Orgiazzi for their contribution to this publication, and to Grégoire Marot, Axelle Corty, and Guillaume Morel for their generous assistance.

The Façades of Paris
Windows, Doors, and Balconies

First published in the United States of America in 2022 by
Rizzoli International Publications, Inc.
300 Park Avenue South,
New York, NY 10010
www.rizzoliusa.com

Illustrations: © Dominique Mathez

Introduction: Christophe Averty with Joël Orgiazzi

Publisher: Charles Miers
Editorial director: Catherine Bonifassi
Art direction: Patrice Renard
Editor: Victorine Lamothe
Production director: Maria Pia Gramaglia
Managing editor: Lynn Scrabis

Editorial coordination:
CASSI EDITION
Vanessa Blondel, Candice Guillaume,
Devorah Lauter, Coline Richard

All rights reserved. No part of this publication may be reproduced,
stored in a retrieval system, or transmitted in any form or by
any means, electronic, mechanical, photocopying, recording, or
otherwise, without prior consent of the publisher.

ISBN: 978-0-8478-7160-5
Library of Congress Control Number: 2021945303
2022 2023 2024 2025 / 10 9 8 7 6 5 4 3 2 1
Printed in Italy

Visit us online:
Facebook.com/RizzoliNewYork
Instagram.com/RizzoliBooks
Youtube.com/RizzoliNY
Twitter: @Rizzoli_Books
Pinterest.com/RizzoliBooks
Issuu.com/Rizzoli